LEGACY OF THE MINE

ILAN GODFREY

2017

CONTENTS

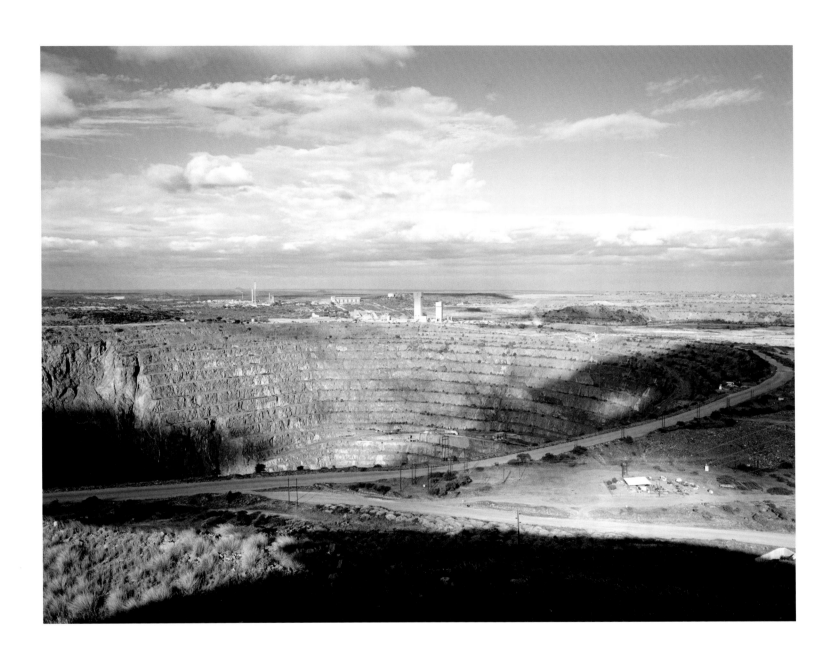

Palabora Copper Mine, Phalaborwa, Limpopo, 2013.

THE PEOPLE SHALL
SHARE IN THE
COUNTRY'S WEALTH.
"THE MINERAL
WEALTH BENEATH
THE SOIL, THE BANKS
AND THE MONOPOLY
INDUSTRY SHALL BE
TRANSFERRED TO THE
OWNERSHIP OF THE
PEOPLE AS A WHOLE."
*THE FREEDOM
CHARTER, 1955*

The Long (and Dark) Shadow of Mining in South Africa

Sakhela Buhlungu

For nearly 150 years the mining industry has been the catalyst for South Africa's economic development and therefore the country's proverbial goose that lays the golden egg. The discovery of diamonds in the late 1860s set in motion the country's own industrial revolution and was followed soon thereafter by the discovery of gold on the Witwatersrand and other minerals in far-flung parts of the country. To this day the industry continues to cast a long shadow over the South African economy, with those parts of the country and economy linked to mining being the greatest beneficiaries. The aptly named province of Gauteng (place of gold) remains the powerhouse of the economy with some of the largest concentrations of wealth and economic activity on the African continent. Of course this wealth has trickled down to other parts of the country and the southern African region; the province retains its mesmerising attraction for tycoons, adventurers, displaced peasants, crooks and criminals from all over the world. Thanks to mining, the country has the largest economy on the continent and boasts cities, financial institutions, infrastructure and technological advances that can hold their own among the best in the world.

Not long after the discovery of minerals, mining outstripped farming as the most important industry in the economy. It also triggered the massive growth of the manufacturing sector and rapid urbanisation of the population as a result of people moving from the land into towns and the arrival of thousands of immigrants, particularly from the United Kingdom, the United States and Australia. The long shadow of mining extended beyond the shores of South Africa and resulted in the internalisation of the economy through linkages such as trade, the sourcing of machinery and skills. These linkages made the country an important player in the international division of labour and increased its attraction for investors, trading partners and unskilled, skilled and professional and managerial employees.

A MAJOR EMPLOYER

South Africa is well endowed with a wide range of minerals, the most abundant and strategic being gold, diamonds, iron ore, platinum, copper and coal. Although it is no longer the dominant mainstay of the economy, the industry creates hundreds of thousands of jobs, thus providing the livelihoods of millions of people in southern Africa. For more than a century countries such as Lesotho, Malawi and Mozambique have relied on mining for jobs for thousands of their citizens. Even in cases where numbers of citizens from these countries employed by the industry have declined, there are numerous instances where major mining houses continue to run or fund corporate social responsibility projects in Lesotho and certain provinces of Mozambique such as Inhambane, Gaza and Maputo. Within the country many communities, particularly in rural areas and small towns, receive support and donations for various projects, particularly in the area of small business development, housing, health and education. The Mining Charter, a statutory code of targets for good practice promulgated in the early 2000s, encourages these forms of support and empowerment for poor communities in mining areas.

Mining corporations also make huge contributions to human capital development as thousands of young people every year receive bursaries and scholarships for studies at technical college and university. Some mining houses also spend millions of rands every year in funding for higher education institutions, promotion of the arts, and support for sports and recreation.

THE DARK LEGACY OF MINING

In a nutshell, the mining industry has over our history made an enormously important contribution to the South African economy and the economies of its neighbouring countries. It continues to play this role today. However, the long shadow of mining also contains a dark and unpleasant side which often gets lost in narratives that

present the industry's contribution. Below I discuss some aspects of this distasteful legacy. I need to point out that we need to look harder and closer and ask sharper questions to uncover this 'hidden' side of mining. It is hidden because the industry is glamorous, it upsets middle- and upper-class sensibilities, and disturbs commonsense notions of a shared and egalitarian nationhood. In other words, this dark side of mining often gets airbrushed from our day-to-day reality, and where this is not possible, society becomes conditioned and socialised into blaming the victims. Ordinarily, the stories that make up this side of mining do not find their way into front-page newspaper news and, if and when they do, they are presented as examples of the laziness, ignorance and innate violence and barbarism of the victims.

DISPOSSESSION, COERCION AND MIGRANT LABOUR

The flipside of the positive mining narrative is replete with tales of dispossession – land, livestock, birthright – all done for the purpose of forcing thousands of people into wage labour. In other words, for the industry to construct a cheap labour system based on migrancy, the livelihoods of rural communities had to be destroyed so that members of these communities had no other option than wage labour on the mines. For the workers migrant labour was (and, for some, still is) an experience characterised by violence, humiliation and loss of dignity and gross exploitation. The industry also served as a laboratory for those in power to fashion forms of control, some of which were later applied outside the industry. In many ways, therefore, the adversarialism, violence and inequality that we witness today are part of the dark legacy bequeathed to us by the industry.

SOCIAL CONSEQUENCES OF MIGRANT LABOUR

The migrant labour system has been operated for more than a century now. It entailed the tearing apart of families, as men were plucked in their prime and confined to single-sex compounds thousands of kilometres from their homes. This struck at the core of the social fibre of the communities from which the migrant workers came: cultural and religious practices and customs were interrupted, paving the way for the destruction of family structures and the cultural subordination of African societies. The separation of men from their families also created conditions conducive to desertion by some men (*ukutshipha*) and the proliferation of prostitution in the mining towns. Before the 1980s prostitution did not pose a serious threat to the structure of families. But the onset of the HIV/AIDS pandemic from the 1980s had a devastating effect not only on the miners but on their wives and rural communities at large. A brilliant depiction of the deleterious effects of HIV/AIDS on miners and their rural families is to be found in *Yesterday*, a South African movie that won worldwide acclaim for a simple but powerful narrative focusing on an HIV-positive miner and his wife living in a rural KwaZulu-Natal village.

OCCUPATIONAL HEALTH AND SAFETY HAZARDS

Mining also poses serious physical and health hazards for workers. This is particularly so in South Africa because of the deep nature of mining operations. Not only are workers facing constant dangers associated with rock falls, but they are also exposed to respiratory and other hazards caused by the huge amounts of dust underground. Thus over the last century and a half hundreds of thousands of workers have perished from occupational diseases such as silicosis, asbestosis and phthisis, and fatal accidents resulting from rock falls, explosions, gas leaks and underground fires. Thousands of others have been maimed or left unable to work by disabling injuries suffered on the mines. The tragic story of occupational and health hazards does not end with workers who are diagnosed while still in employment or those who are injured or die at work. Thousands more retire or are retrenched from the mines unaware that they have contracted mine-related respiratory diseases. Most of these workers only learn of their diseases some months or even years after they have left mine employment. As a result most forfeit compensation and occupational health care and assistance by their former employers, and perish under conditions of abject poverty in remote rural villages of southern Africa.

MANUFACTURED DIVISIONS

Although the industry did not invent divisions, it made use of existing forms of discrimination to further its profit-making goals. Divisions between black and white workers were deepened and translated into a two-tier labour force made up of, on the one hand, a vast pool of cheap unskilled black labour and, on the other, a small labour aristocracy whose high wages and privileges derived not only from their skill but also from their skin colour. The former were politically disenfranchised and were denied basic rights such as the right to form trade unions, while the latter enjoyed political citizenship (including the right to vote) and industrial citizenship (the right to organise and form trade unions). These divisions constituted white workers as insiders and black workers as outsiders. This state of affairs prevailed because of collusion between white mineworkers and mine employers known as 'job reservation' or the 'civilised labour policy'. When employers reneged on this arrangement white miners waged one of the most violent industrial actions the country has known, the Rand Revolt of 1922.

Mine employers also used other forms of divide and rule. Black workers were categorised into ethnic groups on which residential arrangements in mine compounds were often based, including the use of the so-called *induna* system. In traditional governance structures the *induna* was an appointee of the chief who managed sections of the community on the chief's behalf. In the mine compounds *indunas* were appointed by the (white) compound manager to control members of their 'tribe'.

Ethnicity was often mobilised, with the tacit agreement of mine management, to foment conflict between and among ethnic groups. These 'faction fights' almost always led to the death and injury of many workers. These conflicts only abated towards the end of the 20th century following a campaign by the National Union of Mineworkers (NUM) to end ethnic conflict and build class-based solidarity among black workers.

ENVIRONMENTAL DEGRADATION

Mining poses one of the greatest dangers to the environment, ranging from water pollution to the production of radioactive waste and the creation of waste dumps and open pits. The Free State Gold Fields, in the Welkom–Virginia–Odendaalsrus triangle, once considered to contain some of the richest gold deposits, are reaching the end of their lifespan thus causing some mining companies to abandon their ageing mines. In the process, many communities are left exposed to the dangers of radioactive mine dumps and unstable slime dams. Fracking, a new form of mining for gas, poses the threat of pollution of ground water. Coal mines, particularly those in parts of Mpumalanga, are notorious for the sinkholes and underground fires that they leave behind, years after mining operations have ceased. These conditions present dangers to humans and livestock.

A fact less commonly known among the public is that mining operations require inordinately large amounts of water, for which a water-scarce country like South Africa needs to plan carefully. Failure to plan may result in a water crisis for the country much sooner than most realise. The expansion of mining to extremely dry regions such as parts of the North West and Limpopo provinces could exacerbate this problem.

SUBCONTRACTING, THE NEW FACE OF EXPLOITATION

The mining industry has moved from an age of severe labour shortage to one of labour surplus, characterised by extremely high levels of unemployment. In the first 90 years of its existence mining went through one phase of labour scarcity to another. Different strategies and instruments were used to get labour for the mines, including taxation, land dispossession, pass laws, the use of Chinese indentured labour, and the large-scale recruitment of workers from neighbouring countries, particularly Lesotho, Mozambique and Malawi. However, the 1970s marked a turning point as labour conditions turned from shortage to surplus.

Notwithstanding these changes, the formation of the NUM in 1982 and its spirited campaign to improve wages and conditions for black workers reduced opportunities for management to make use of old cheap-labour methods. In the light of these constraints, mine employers sought new ways to achieve flexibility in employment that circumvented the regulated environment imposed by the unions for black employees. Subcontracting presented itself as a solution and has expanded massively over the last two decades, with subsectors such as platinum recording nearly 40 per cent of the workers employed by subcontractors.

GHOST TOWNS AND NEW FORMS OF DISORDER

All mining operations have a limited life span that depends mainly on the quantity of mineral deposits as well as the financial viability of mining them. The older mining regions have seen some of their mines close down for one or other of the reasons mentioned above. But it is the Free State Gold Fields that presents the dilemmas of old mining towns most graphically. The two main towns, Welkom and Virginia, have virtually become ghost mining towns as most of the mine shafts have closed down. What gives the towns a more eerie image are the abandoned mine compounds, many of which lie in ruins, as people strip them of every conceivable piece of reusable material, from bricks and corrugated-iron roofing sheets to plumbing materials and other fittings. Most local residents are able to point out to visitors some of the impressive houses built from these recycled materials.

Meanwhile, hundreds of locals and migrants from as far as the Eastern Cape, Lesotho and Mozambique scavenge along disused railway tracks, mine dumps and headgear for rocks with some gold content. Locals call them Zama-Zamas, the people who keep on trying to make a living. But there are different kinds of Zama-Zamas, and the most daring are known to live underground and mine illegally for months at a time without coming to the surface. These are said to be connected to powerful local and international syndicates and have the means to intimidate and bribe their way out of any difficult situations they encounter. Apparently, even police officers and powerful union leaders are scared of them.

RESISTANCE TO MINING EXPLOITATION AND GREED

It must be noted that for over a century some of these negative aspects of the industry have met with resistance from workers in the industry as well as members of communities and civil society organisations. The earliest instances of resistance were the demands of white workers for better wages. The most spectacular action by these workers was the 1922 strike, in which they engaged in bloody battles with mining companies and the state. An important aspect of the strike was that white mine workers demanded job reservation for themselves at the expense of black workers. But it was the resistance by black workers that dominated the 20th century and culminated in the formation of the National Union of Mineworkers in 1982 and the epic wage strike of 1987, which some dubbed '21 days that shook the Chamber [of Mines]'. But the struggle that will remain etched in the memories of many South Africans is the 2012 massacre of 34 mineworkers by the police at Lonmin's Marikana mine.

Not only does organised protest by mineworkers focus on the exploitative relations between employers and employees, it also shows that the positive contribution of mining – such as economic development, job creation and corporate social responsibility – is founded on the industry's negative aspects, some of which have been noted earlier in this discussion.

MINING AFTER MARIKANA

Marikana has become a turning point in the history of the industry, in that it has awakened all involved to the reality of the persistent legacy that not even the much-vaunted post-apartheid labour legislative regime has been able to eradicate. In a word, the Marikana struggle and the resultant massacre have focused once again on

the dark side of mining – the cheap labour system, migrant labour, the use of brutal force against workers, collusion between employers and the state, the divide-and-rule tactic, deplorable living conditions for mineworkers, and racism. The groundswell of sympathy and support for the cause of the Marikana strikers is an indication that even members of the broader public subscribe to the view that the industry ought to continue to play its role of community responsiveness, through the creation of employment and the empowerment of the general population. However, it also needs to provide decent work conditions for its members and healthy and safe conditions for communities in mining areas.

In recent years the nationalisation debate has resurfaced with regard to the mining industry. But what has been missing in the debate is whether and how nationalisation will help clear the dark side of the industry. Will it do away with the compound system? What about migrant labour and the cheap labour system? Will it help accelerate employment equity and affirmative action?

A positive development of the post-apartheid period is that many former and current mineworkers have ascended to positions of power and influence. They range from officials in local government to those in provincial government structures and ultimately national government. But how do these officials and worker-dominated structures help eliminate the legacy of the past? Research in mining areas shows that former and current miners in positions of authority do not seem to make much of a difference in the day-to-day conditions of mineworkers and their families. In the meantime, these leaders continue to enrich themselves in ways very similar to those of mine owners in colonial and apartheid days.

SUGGESTED READING
Bezuidenhout, Andries and Buhlungu, Sakhela. 2011. 'From Compounded to Fragmented Labour: Mineworkers and the Demise of Compounds in South Africa', *Antipode*, 43, 2, pp. 237–263

Callinicos, Luli. 1980. *Gold and Workers, 1886–1924*. Ravan Press

Donham, Donald L. 2011. *Violence in a Time of Liberation: Murder and Ethnicity at a South African Gold Mine, 1994*. Duke University Press

James, Wilmot. 1992. *Our Precious Metal: African Labour in South Africa's Gold Industry, 1970–1990*. David Philip Publishers

McCulloch, Jock. 2002. *Asbestos Blues: Labour, Capital, Physicians and the State in South Africa*. Indiana University Press

Moodie, T. Dunbar. 1994. *Going for Gold: Men, Mines, and Migration*. University of California Press

THE PHOTOGRAPHS

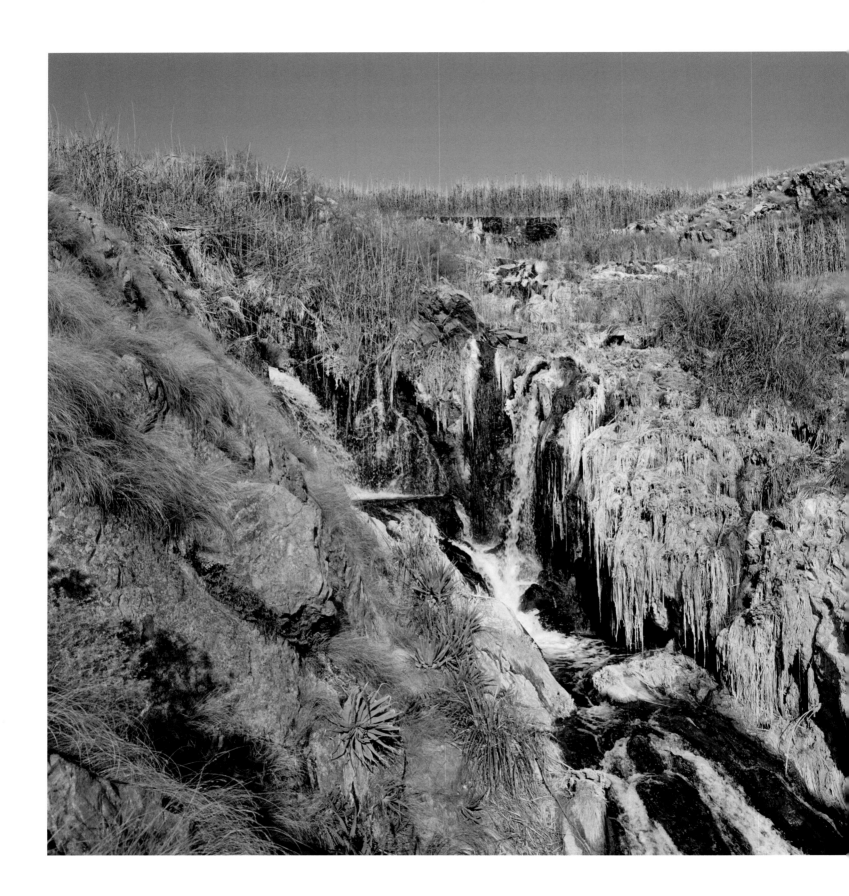

Tweelopie Spruit, Krugersdorp Game Reserve, Gauteng, 2012.

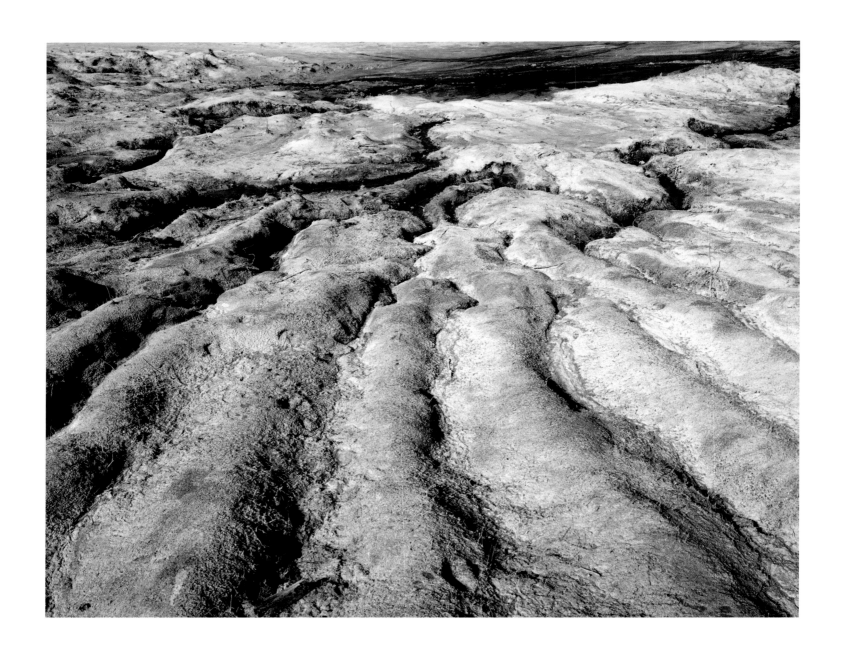

Eroded soil and sulphate deposits, Emalahleni (Witbank), Mpumalanga, 2011.

West Wits Pit, West Rand, Krugersdorp, Gauteng, 2012.

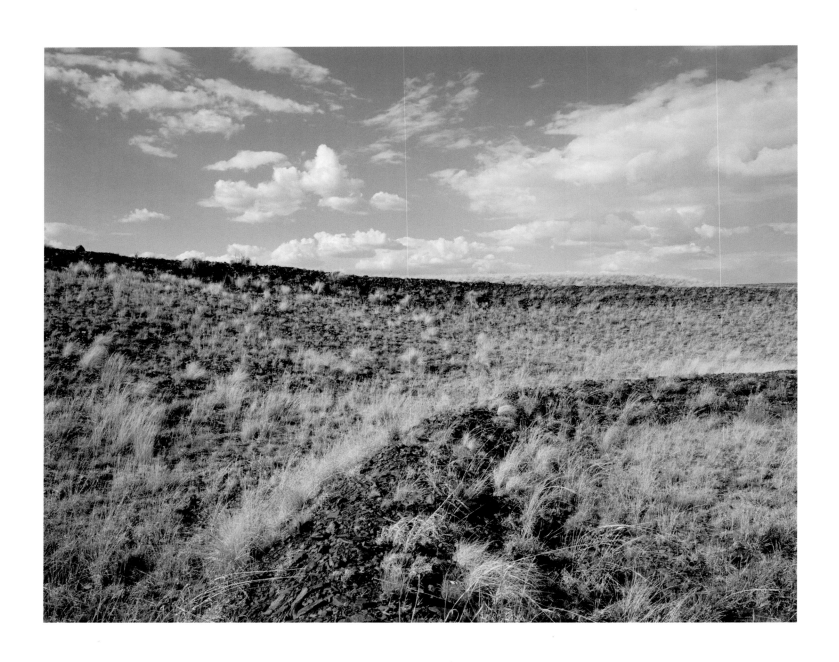

Rehabilitated Danielskuil Cape Blue Asbestos Mine (DCBA), Danielskuil, Northern Cape, 2012.

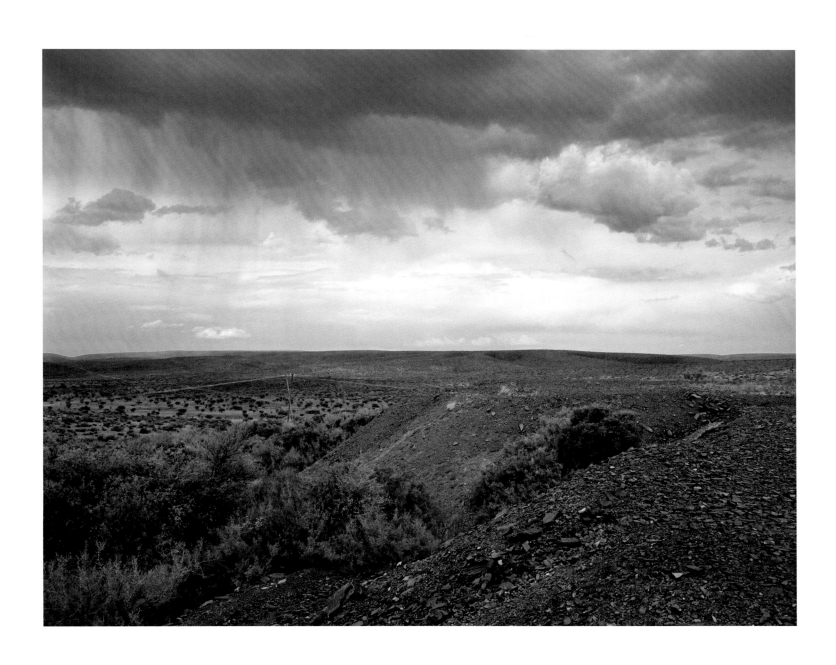

Unrehabilitated Bosrand Asbestos Mine, Northern Cape, 2012.

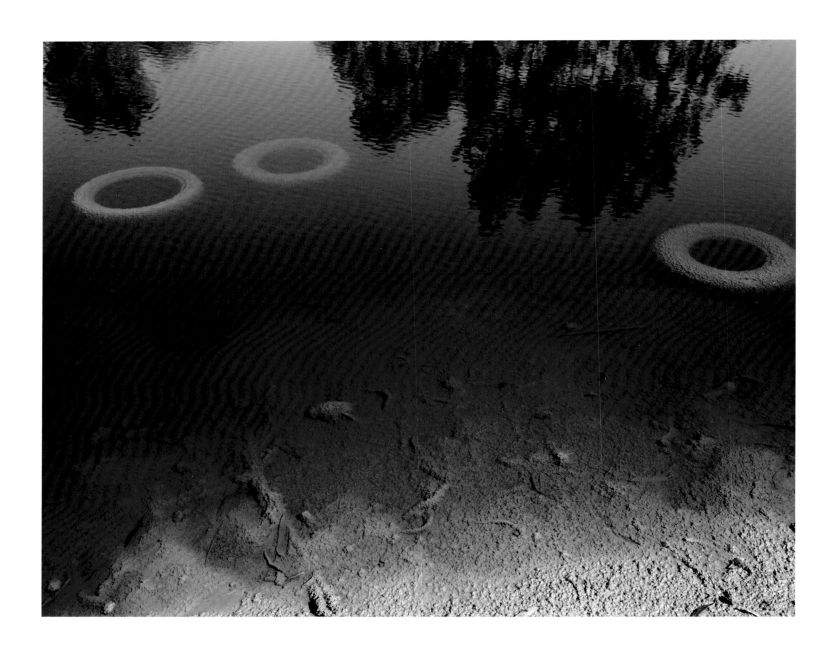

Acid mine drainage, East Rand Proprietary Mine, Johannesburg, Gauteng, 2011.

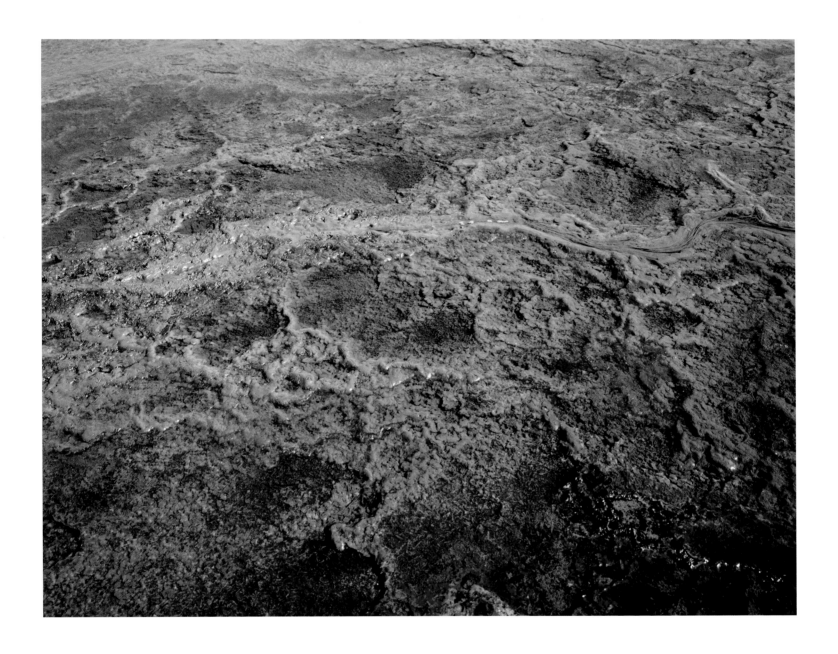

Acid mine drainage, Blesbokspruit, Emalahleni (Witbank), Mpumalanga, 2011.

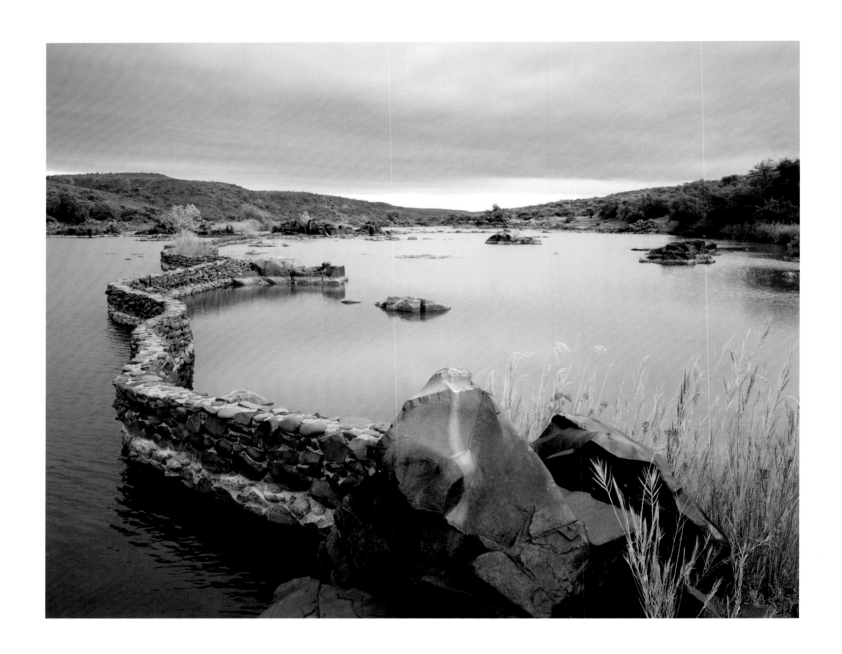

Breakwater, Vaal River, Good Hope Farm, Northern Cape, 2013.

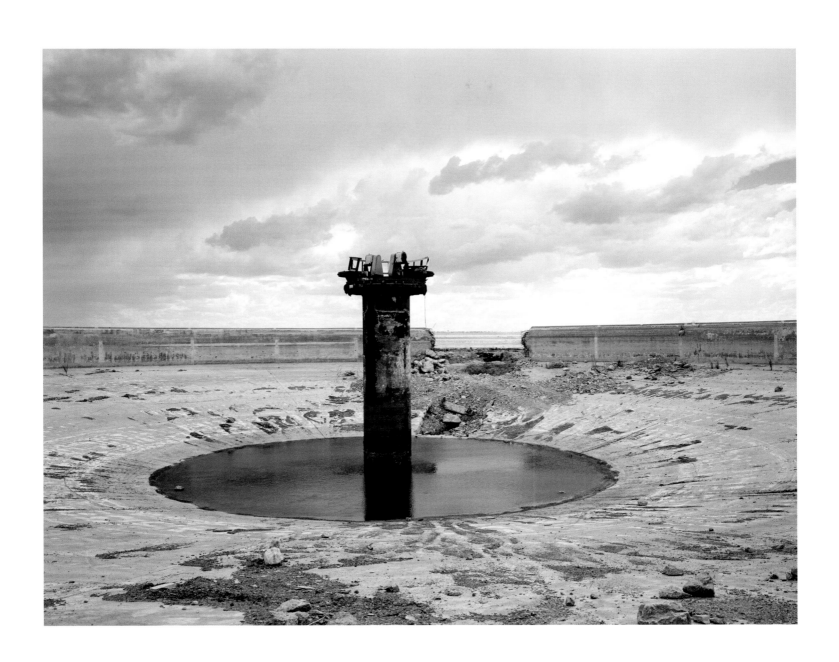

Thickener tank, St Helena Gold Mine, Welkom, Free State, 2012.

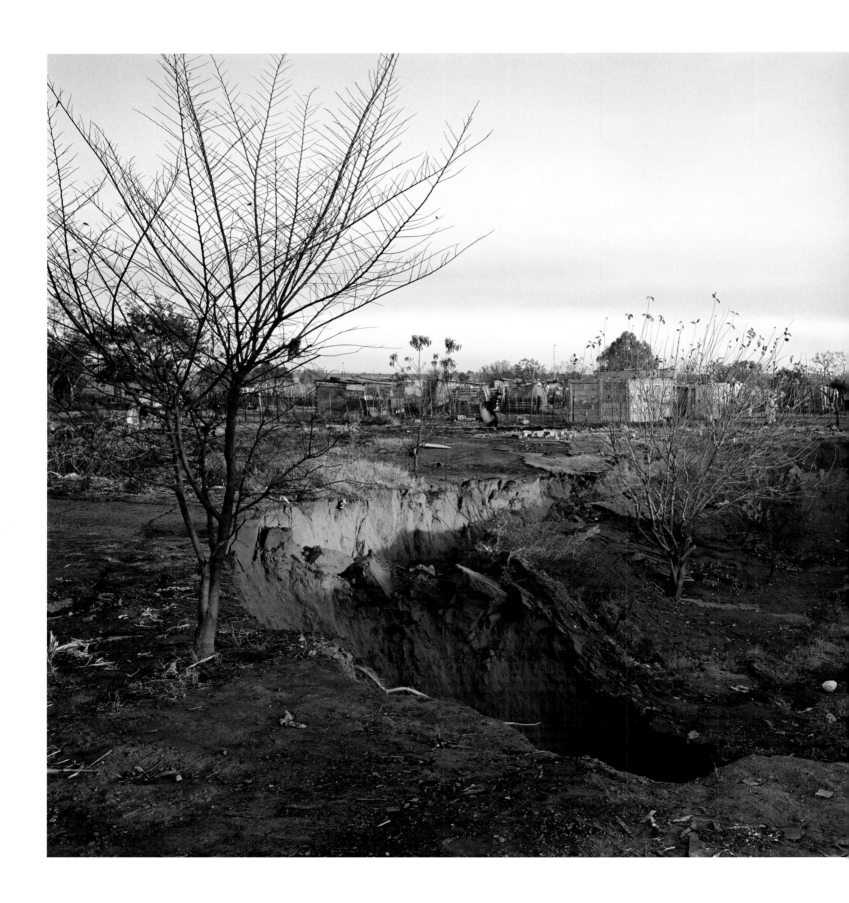

Sinkhole, Likazi, Emalahleni (Witbank), Mpumalanga, 2011.

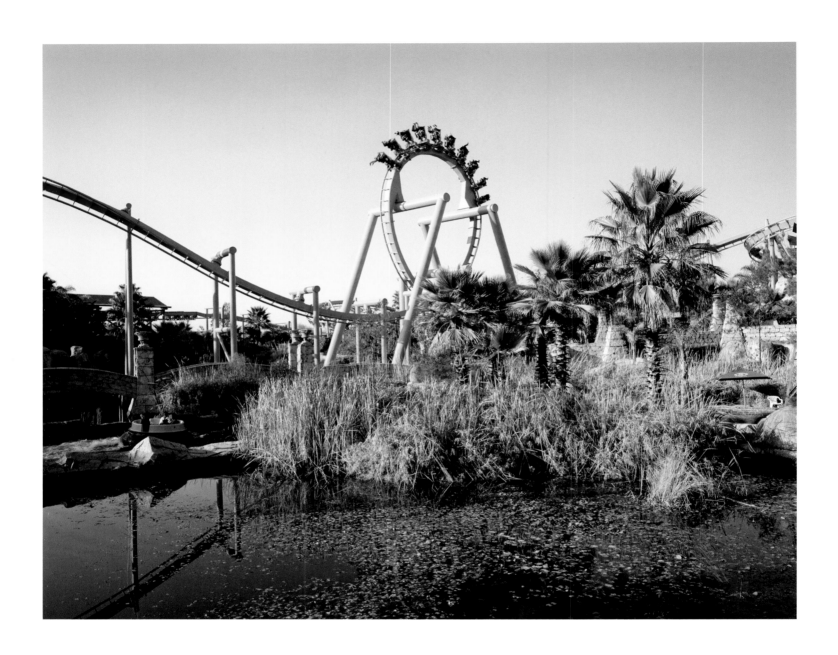

Gold Reef City Theme Park, Main Reef Road, Johannesburg, Gauteng, 2011.

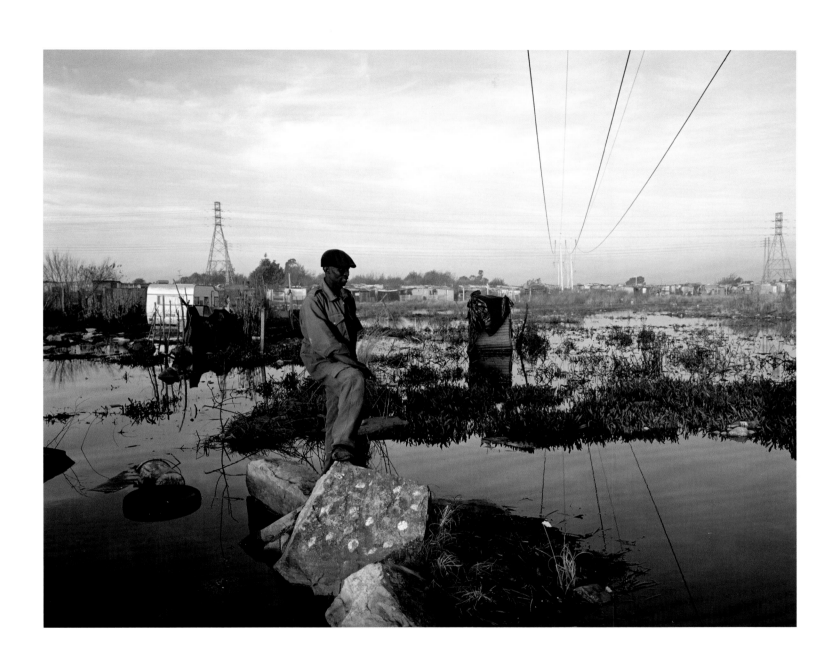

Jeffrey Ramiruti, Tudor Shaft, Mogale City, Krugersdorp, Johannesburg, Gauteng, 2011.

Riverlea mine dump, Main Reef Road, Johannesburg, Gauteng, 2011.

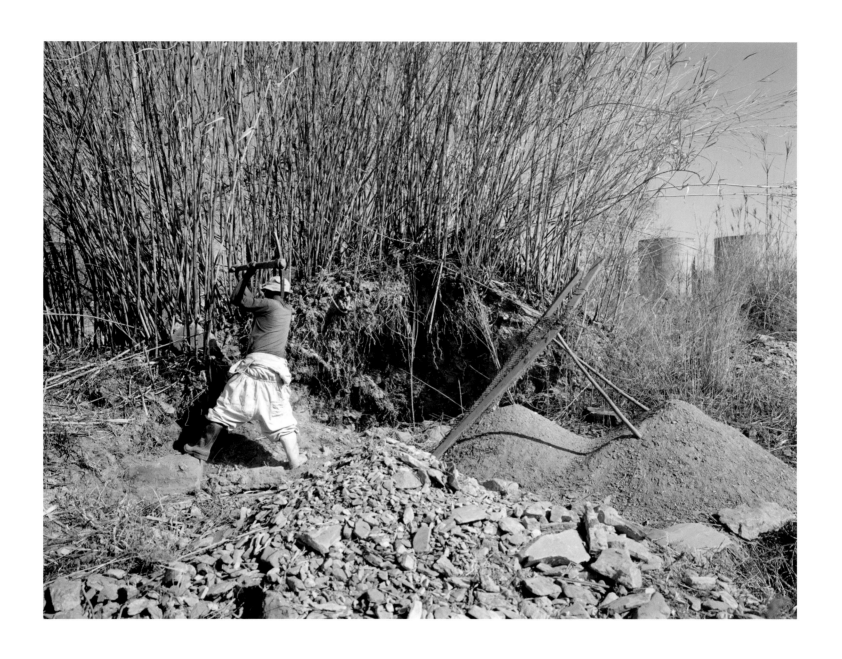

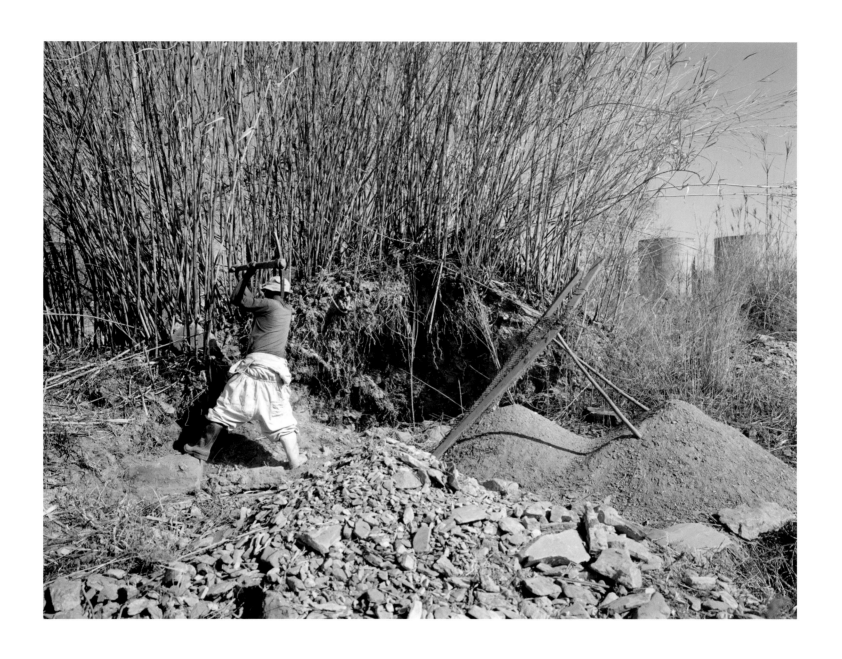

35 Informal digger, disused Daggafontein Gold Mine, Springs, Gauteng, 2011.

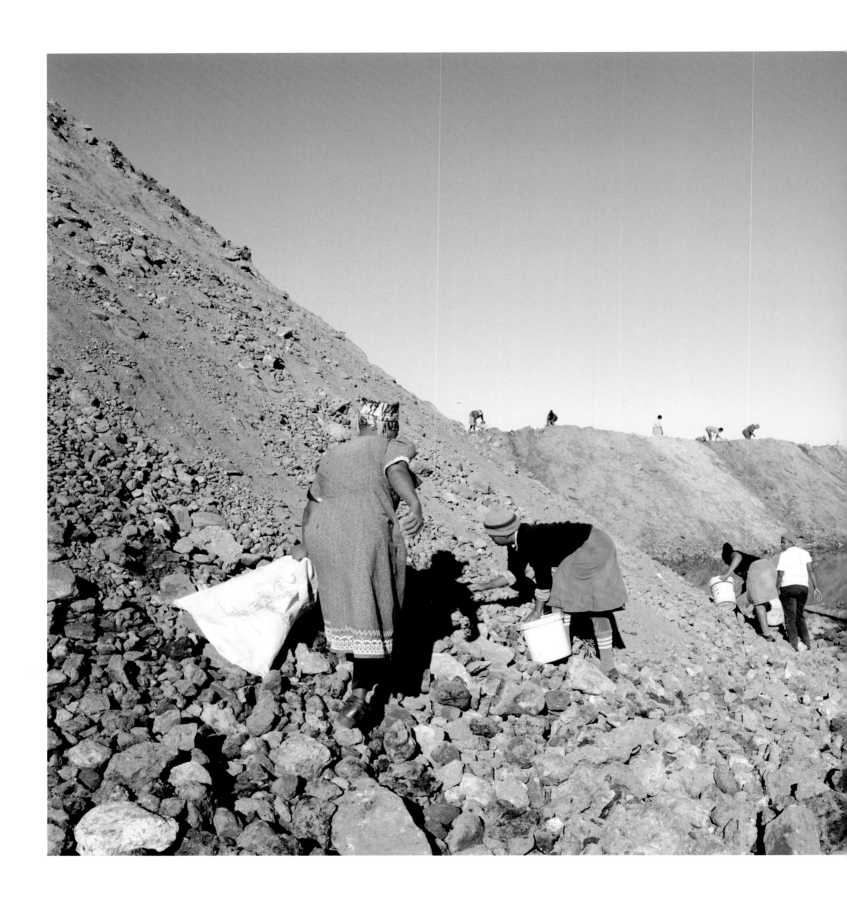

Gathering dirty coal, disused Mashala Mine, Extension Six, Ermelo, Mpumalanga, 2011.

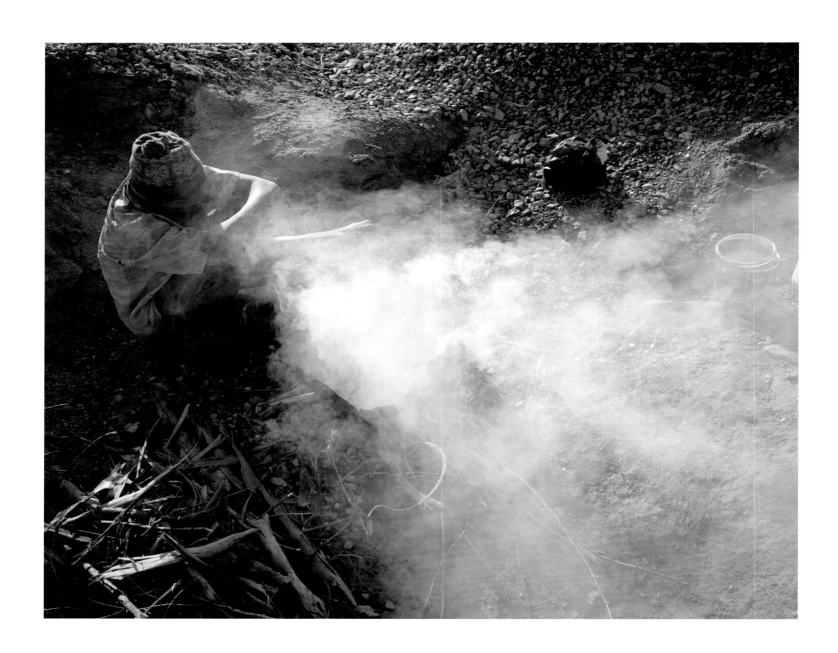

Elias, disused Daggafontein Mine, Springs, Gauteng, 2011.

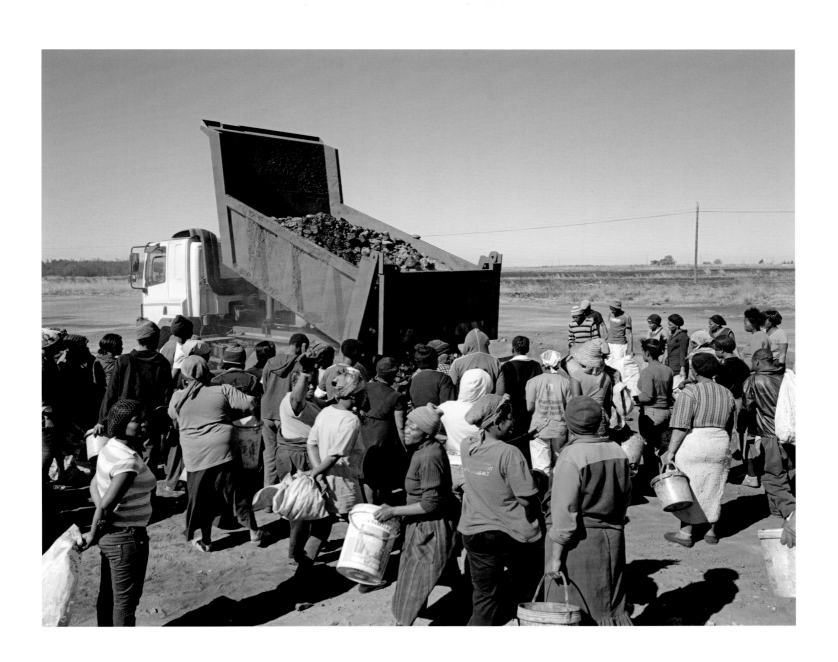

Dirty coal collection, Thusi village, Ermelo, Mpumalanga, 2011.

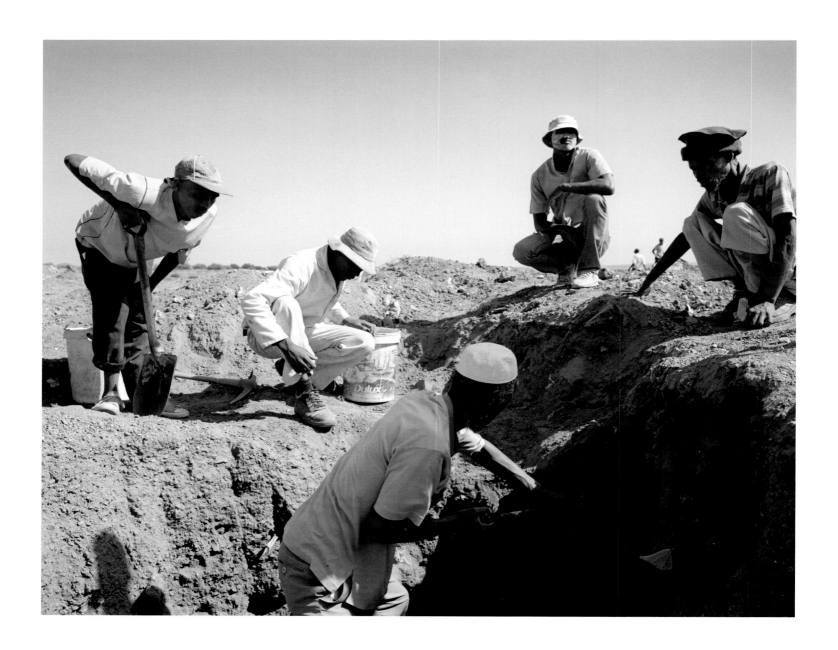

Nylon, Ismaeel, Rafiek, John and Loot, informal diamond diggers, Colville, Kimberley, Northern Cape, 2013.

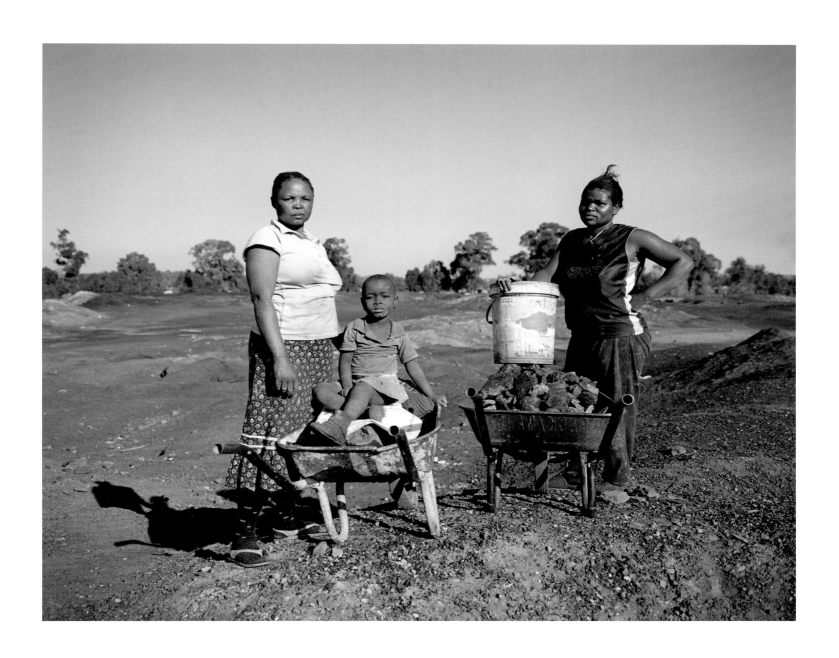

Sylvia, Angel and Setty, disused Coronation Colliery, Likazi, Emalahleni (Witbank), Mpumalanga, 2011.

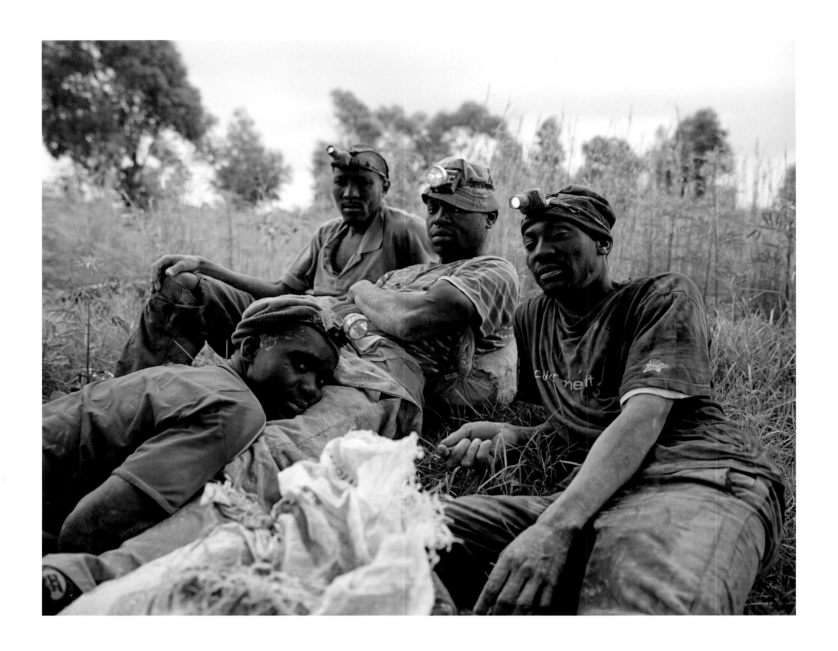

Linda, Daniel, Dumisani and Calvin, informal gold diggers, Roodepoort, Johannesburg, Gauteng, 2013.

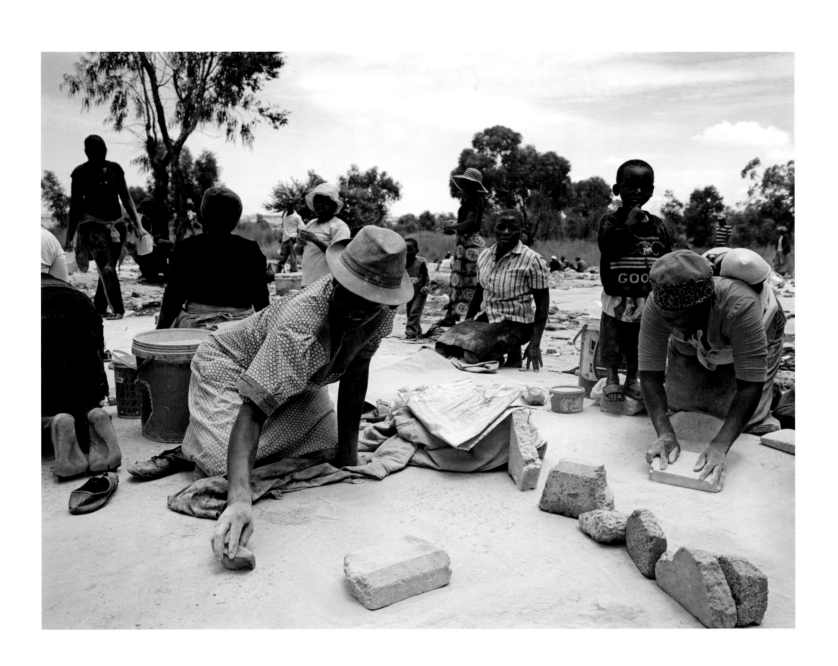

Precious Sibanda, Randfontein Road, Roodepoort, Johannesburg, Gauteng, 2013.

Sandile Dlamini, informal gold digger, Payneville, Springs, Gauteng, 2011.

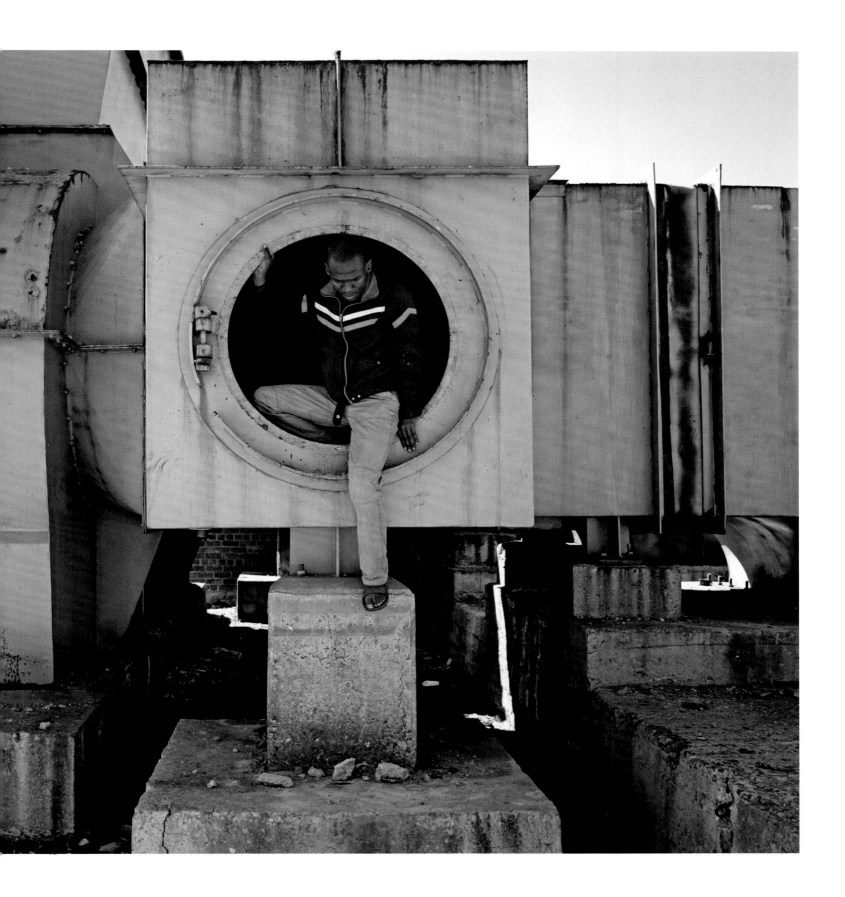

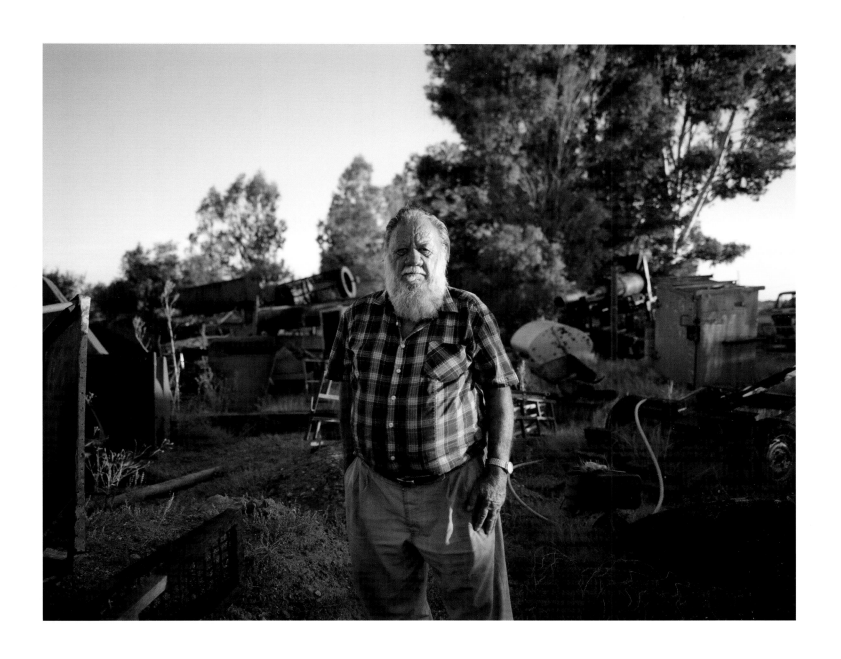

Jan Hendrik van Wyk, diamond delver and farmer, Windsorton, Northern Cape, 2013.

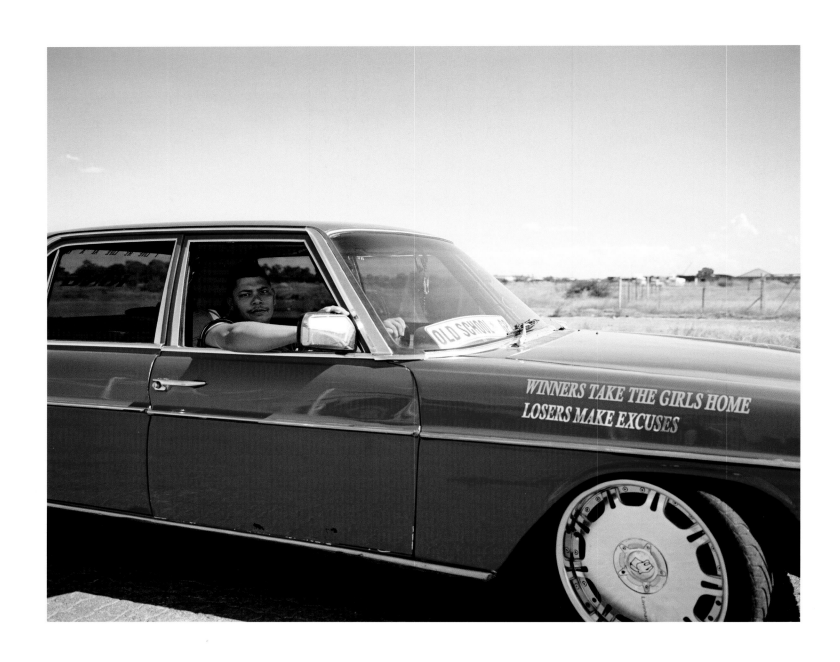

'King G', Transvaal Road, Kimberley, Northern Cape, 2012.

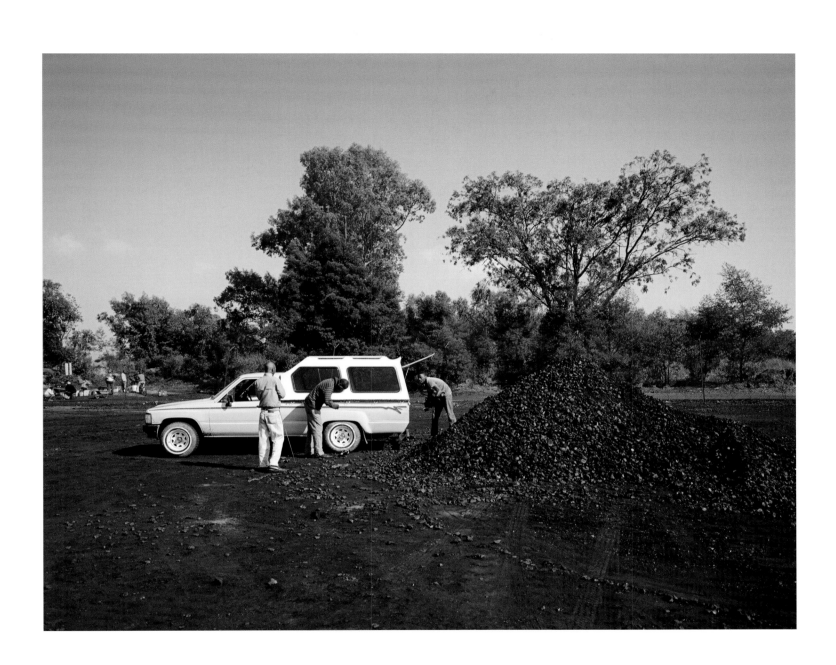

Coal merchants, Slater coal depot, Emalahleni (Witbank), Mpumalanga, 2011.

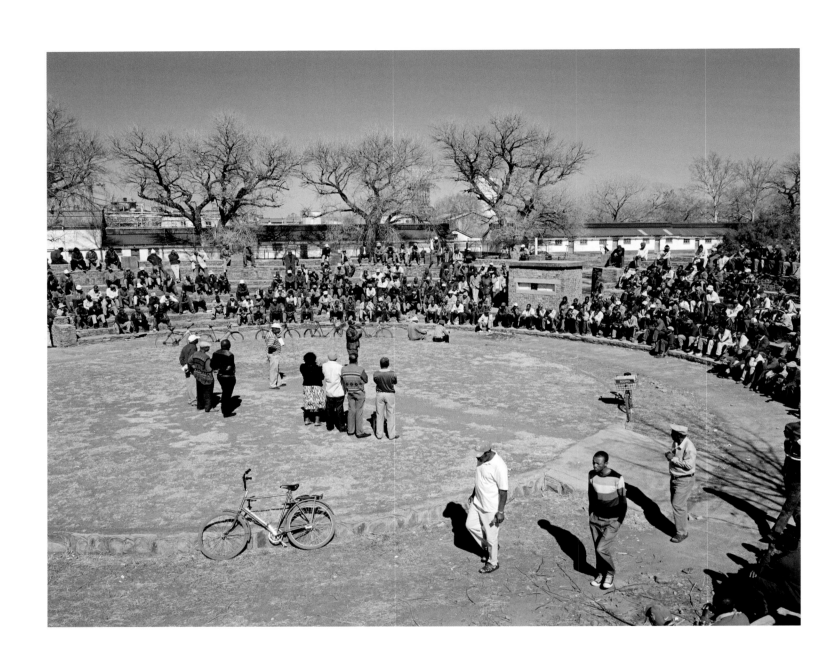

Private meeting, Grootvlei Mine, Springs, Gauteng, 2011.

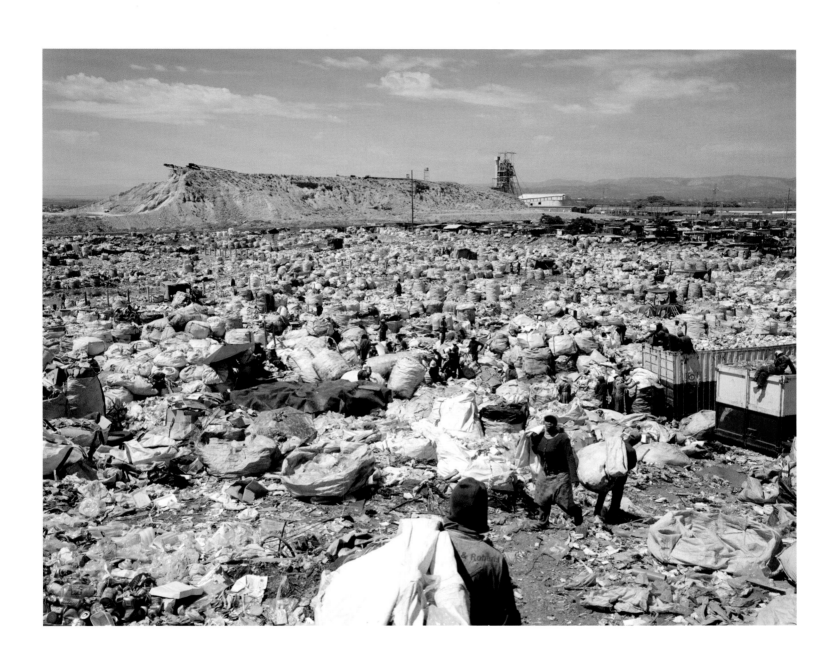

Sondela municipal dumping site, Rustenburg, North West, 2012.

Prayer on Melville Koppies, Johannesburg, Gauteng, 2013.

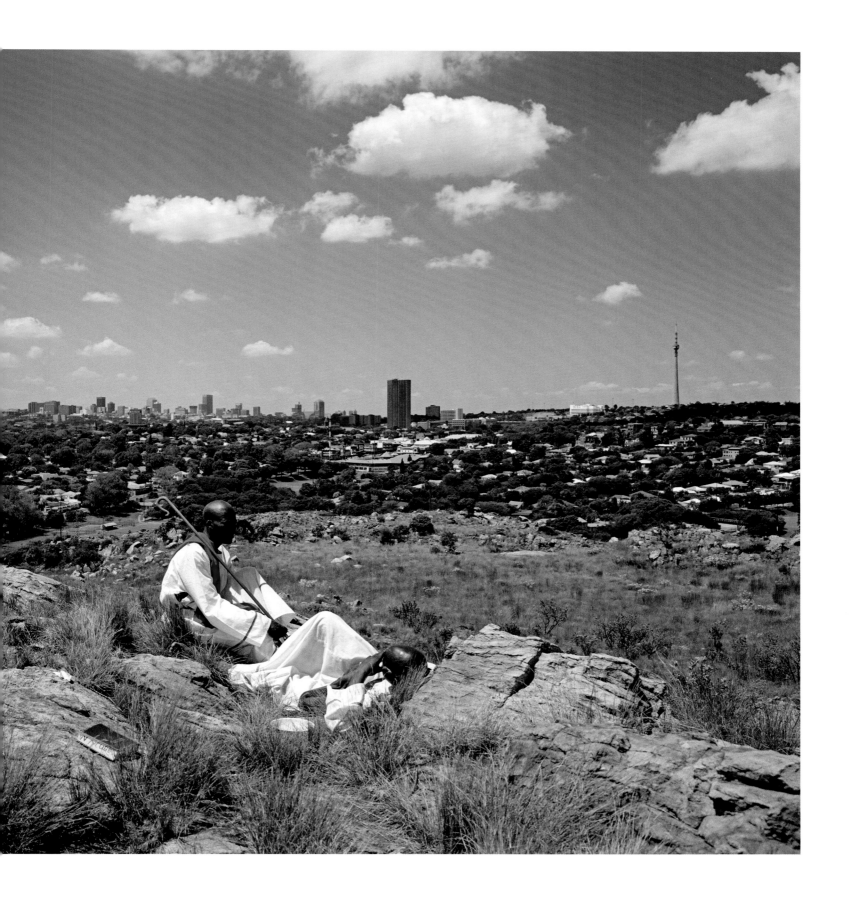

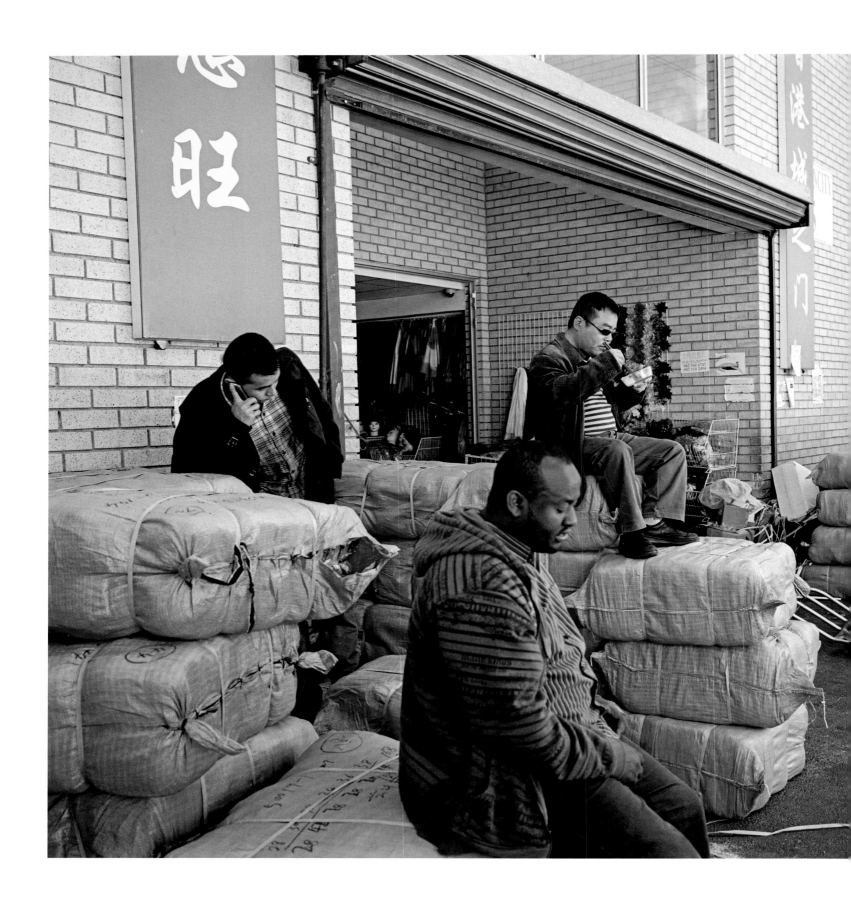

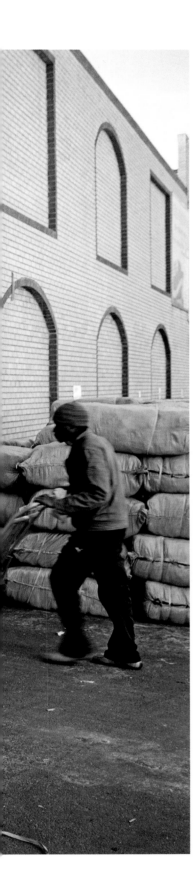

Dragon City, Main Reef Road, Johannesburg, Gauteng, 2011.

Pelou Mwepu-Kalonji, security guard, Dragon City, Main Reef Road, Johannesburg, Gauteng, 2011.

S and M Supermarket and General Dealers, Meyerton, Gauteng, 2011.

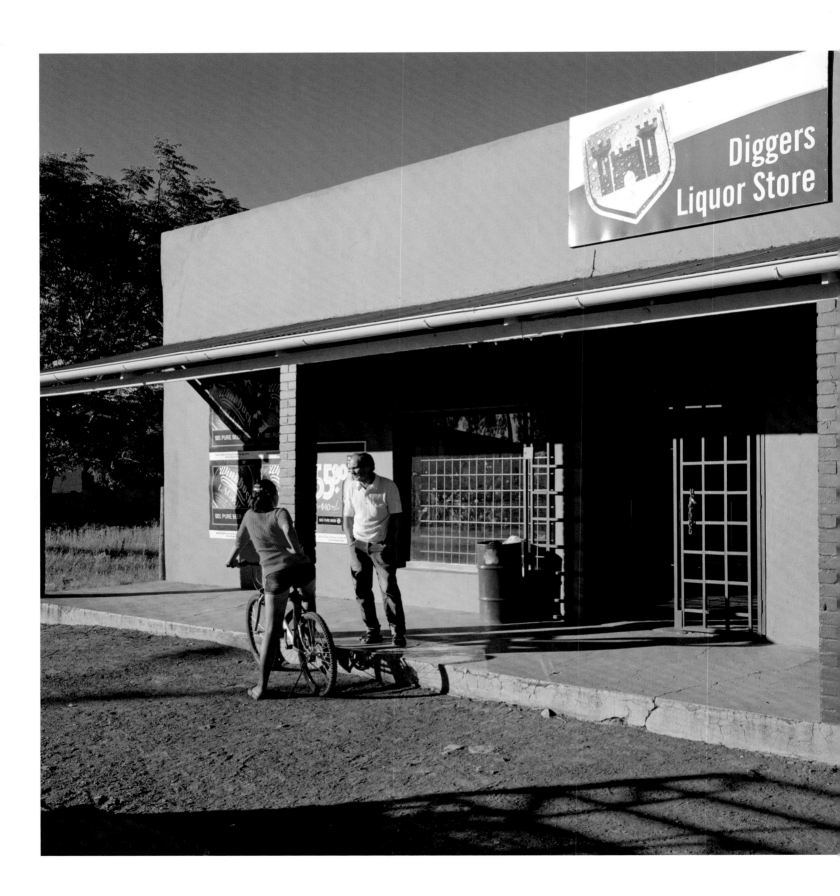

Diggers Liquor Store, Jagersfontein, Free State, 2013.

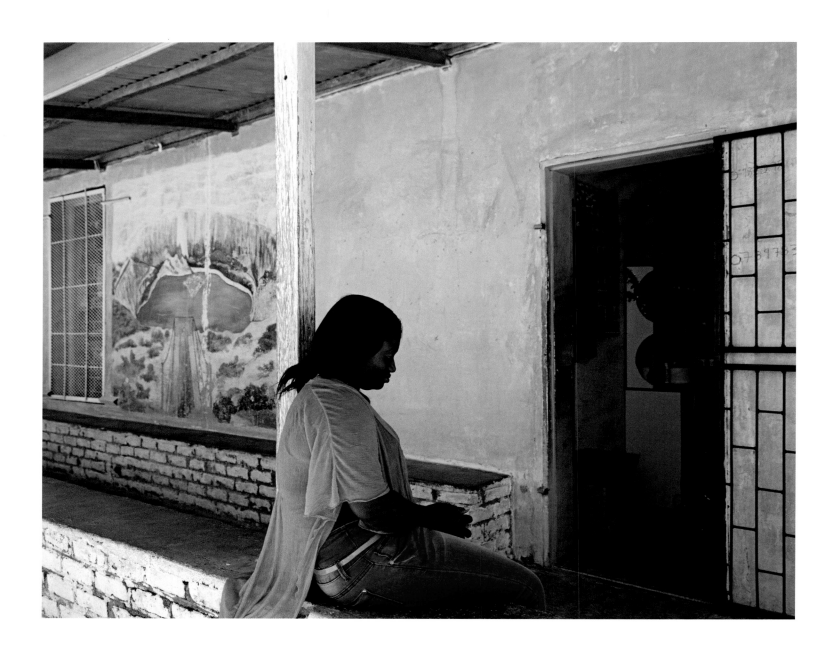

Nana's hair salon, Jagersfontein, Free State, 2013.

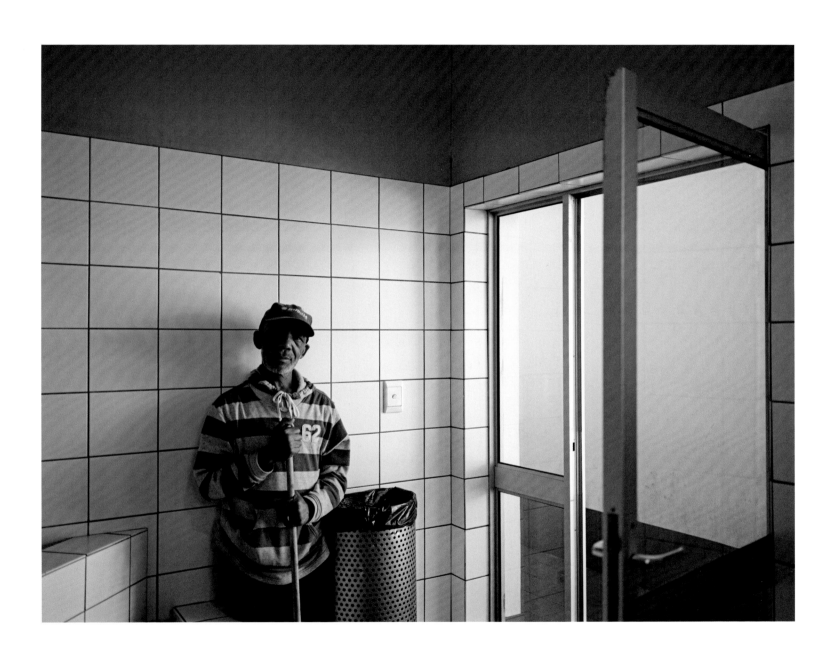

Piet Maans, janitor, Shell Ultra City Service Station, Laingsburg, Western Cape, 2013.

Disused entrance, Marikana, Rustenburg, North West, 2012.

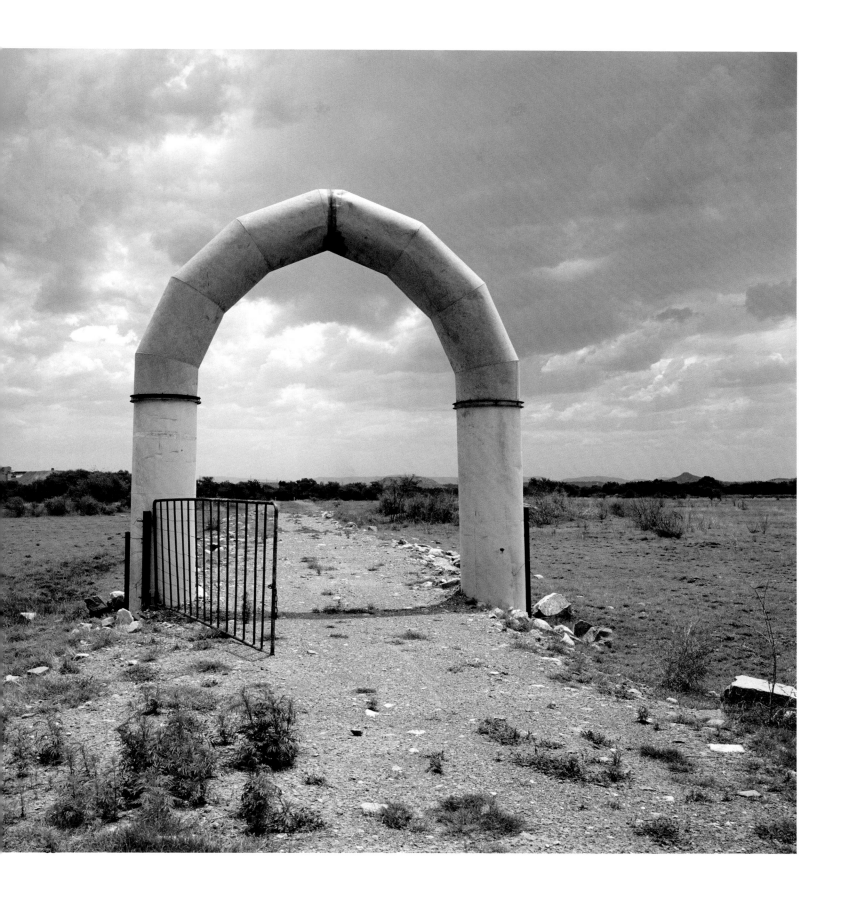

Toxic radioactive steel pipes, West Rand, Krugersdorp, Gauteng, 2012.

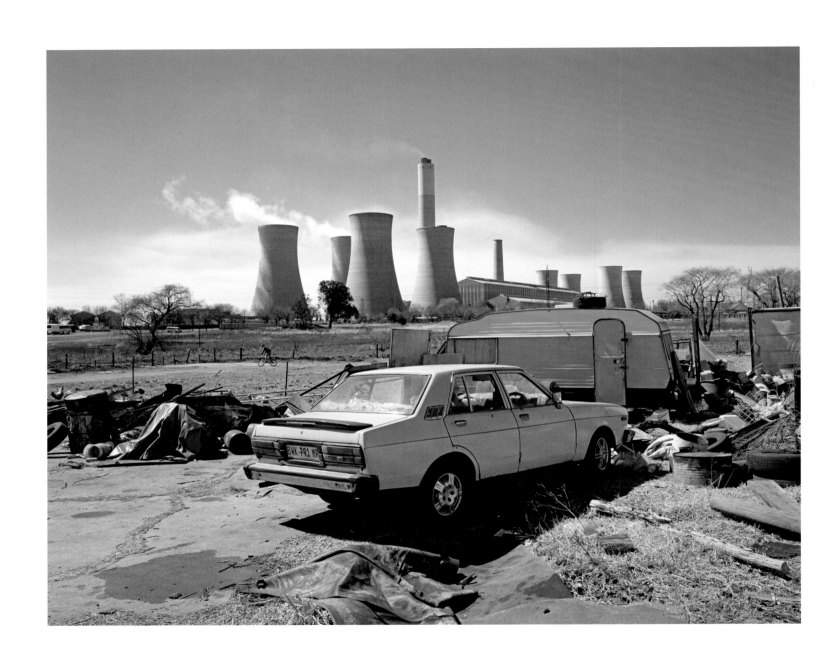

Komati Power Station, Komati, Mpumalanga, 2011.

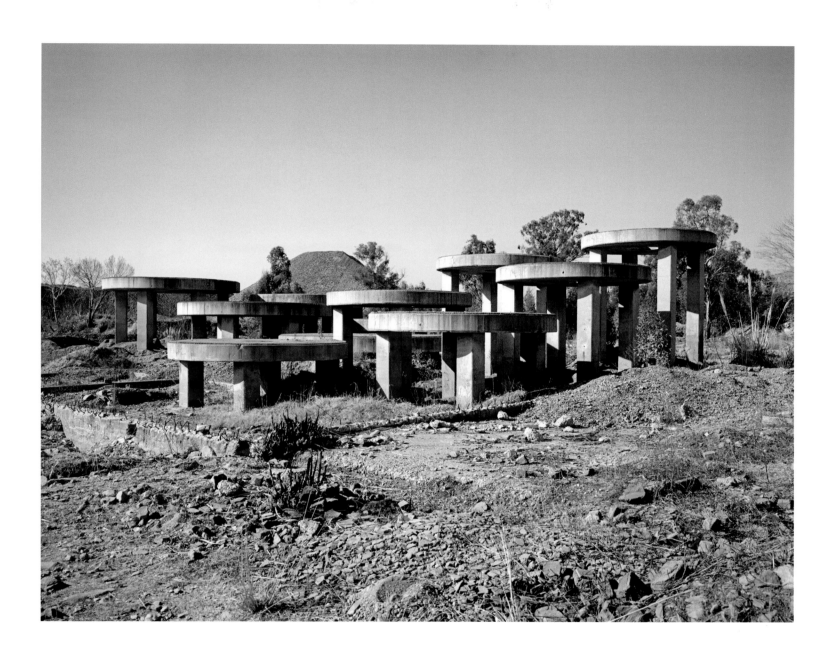

Leach tank foundations, disused Daggafontein Mine, Springs, Gauteng, 2011.

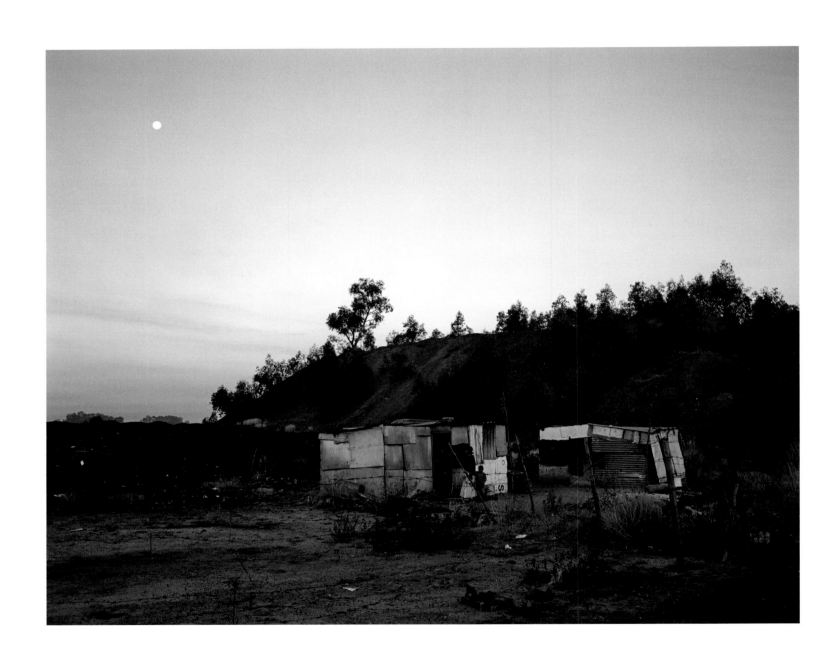

Decommissioned Coronation Colliery, Likazi, Emalahleni (Witbank), Mpumalanga, 2011.

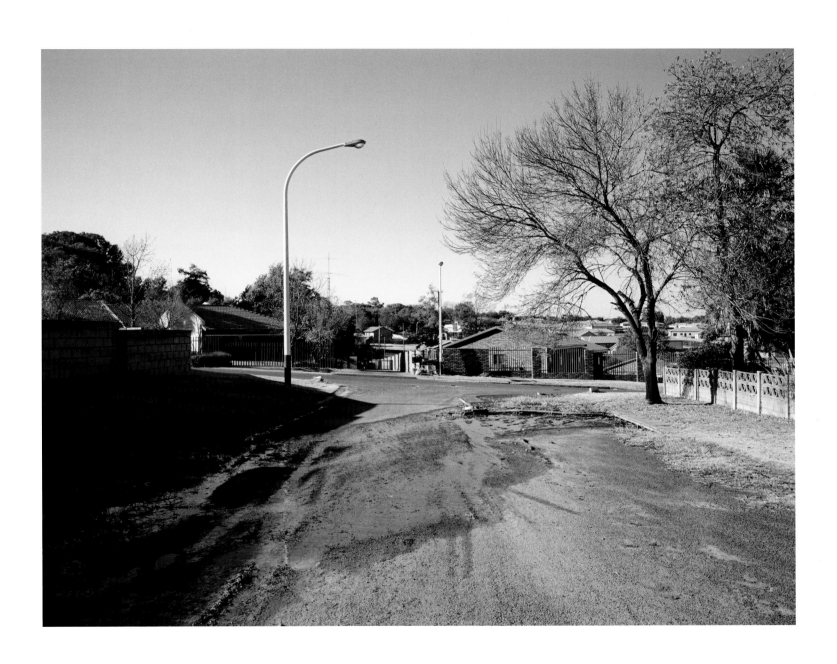

Acid mine water seepage, Jackaroo Park, Emalahleni (Witbank), Mpumalanga, 2011.

Johan Celliss, Ermelo, Mpumalanga, 2011.

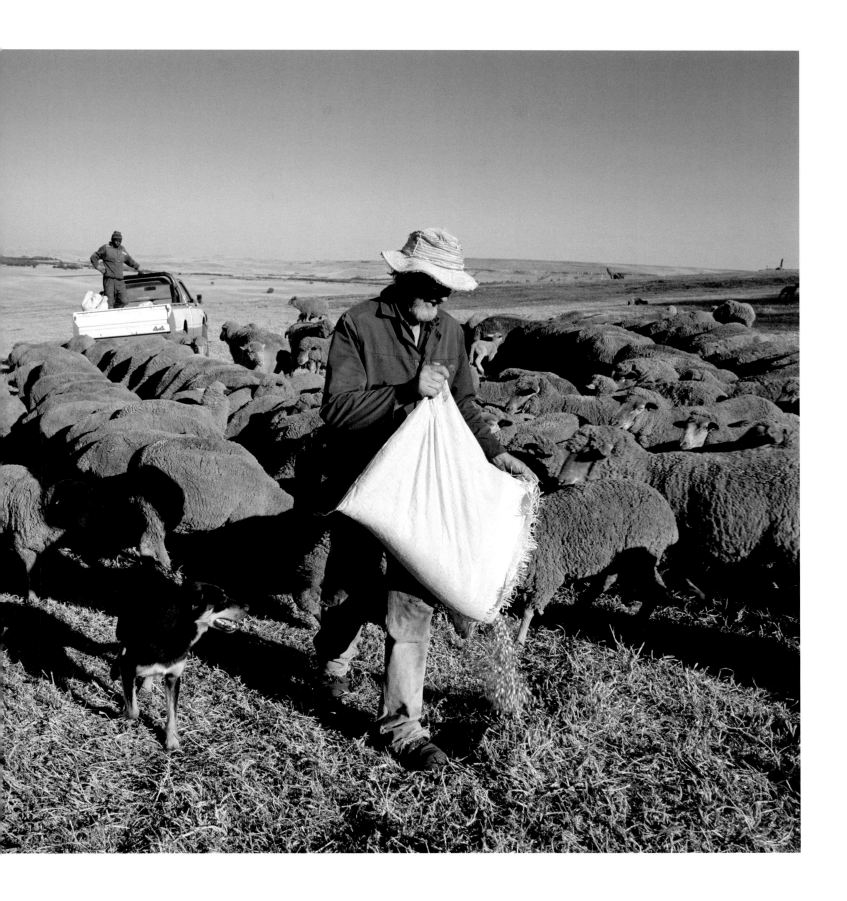

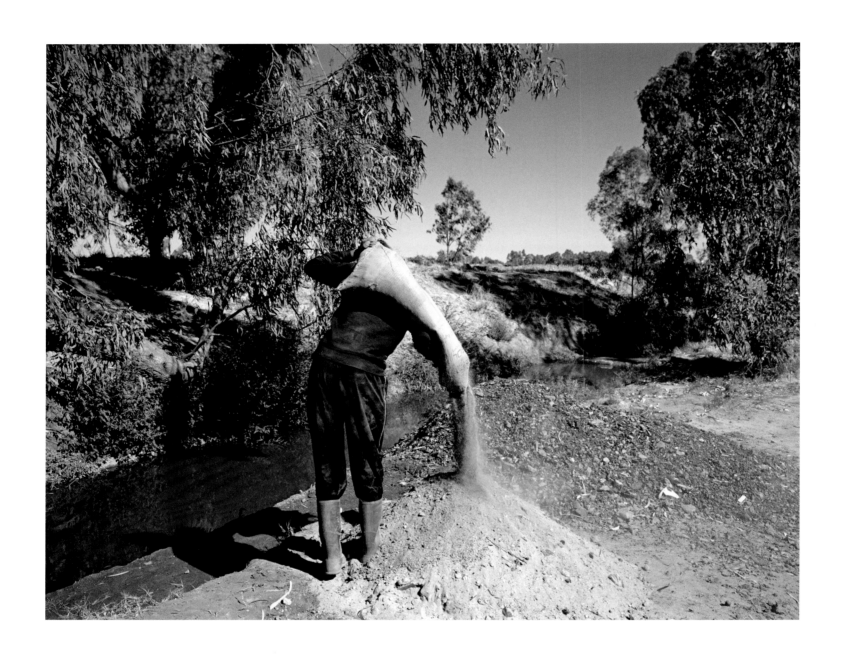

Informal gold digger, disused Western Holdings Mine, Welkom, Free State, 2012.

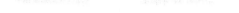

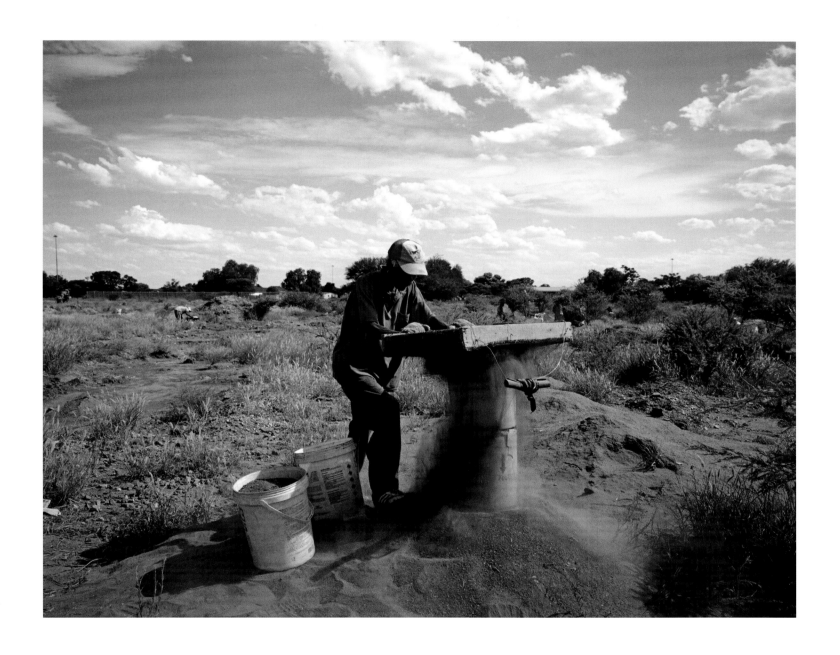

Oupa Koos, informal diamond digger, Floors, Kimberley, Northern Cape, 2013.

Daniel Ndou, Rand Leases Mining Hostel, Main Reef Road, Roodepoort, Gauteng, 2011.

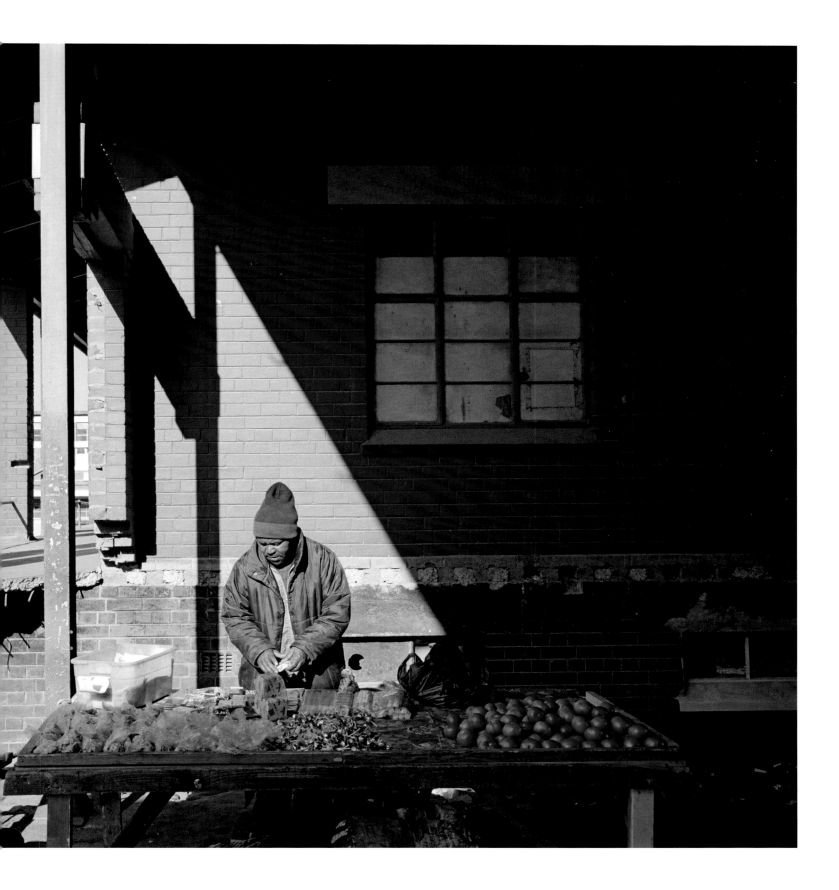

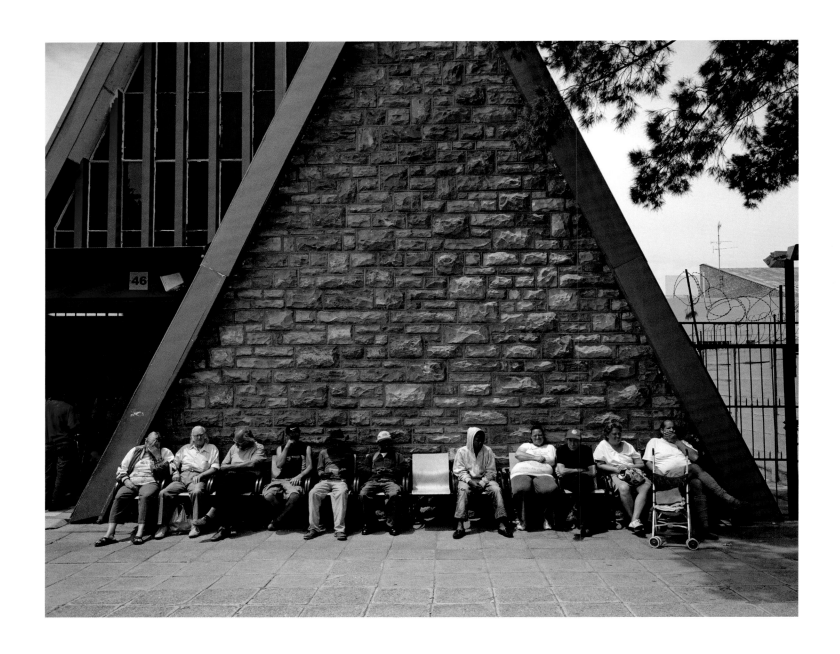

Ikusasa Community Development Centre, Von Brandis Street, Krugersdorp, West Rand, Gauteng, 2012.

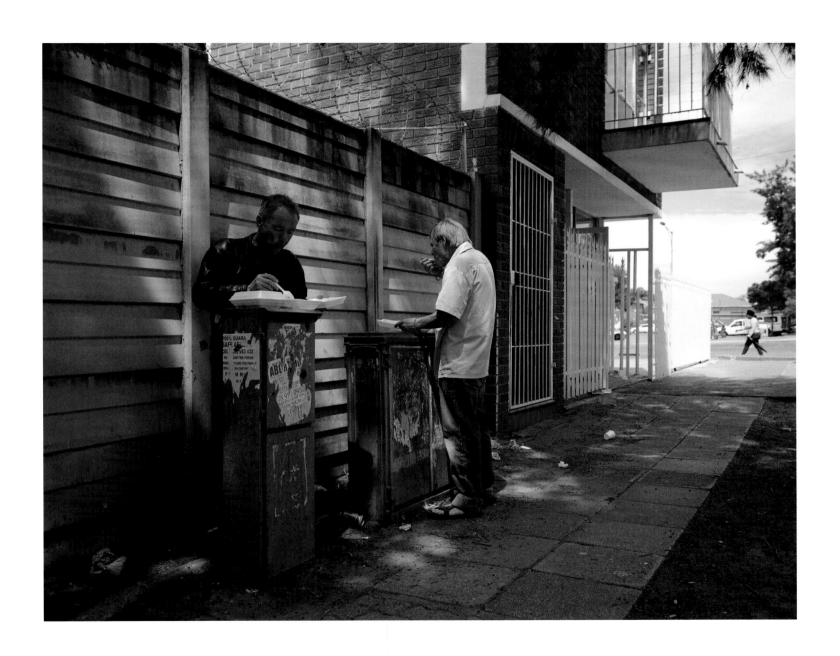

Lionel and Hans, Krugersdorp, West Rand, Gauteng, 2012.

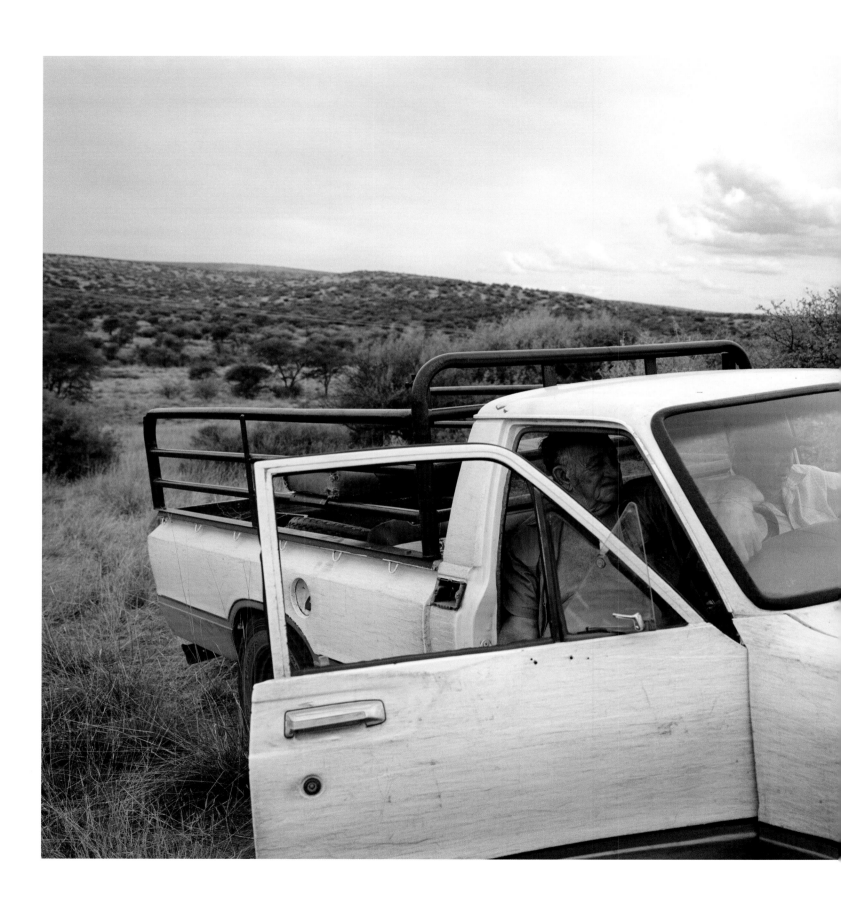

Koot and Daniel Fourie, asbestos victims, Northern Cape, 2012.

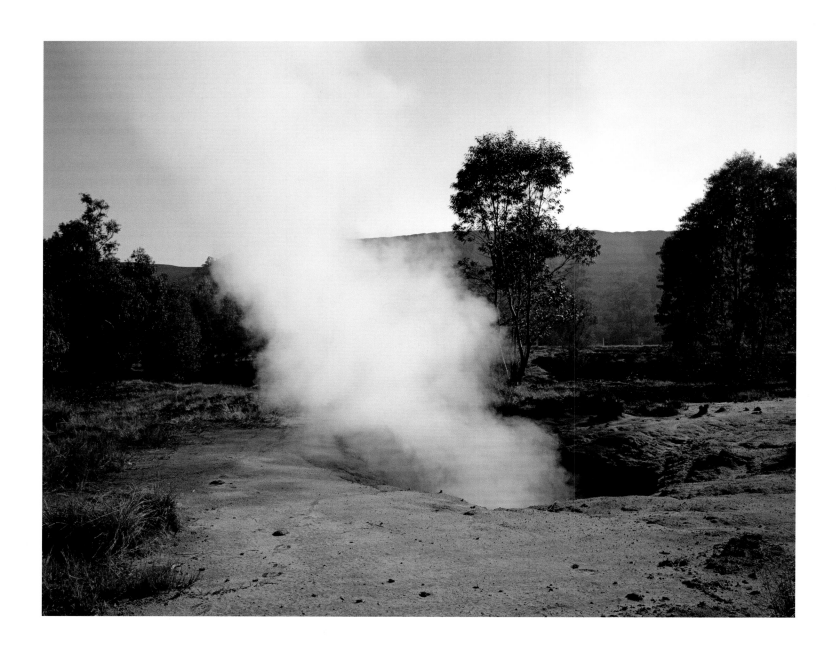

Burning underground coal fires, Emalahleni (Witbank), Mpumalanga, 2011.

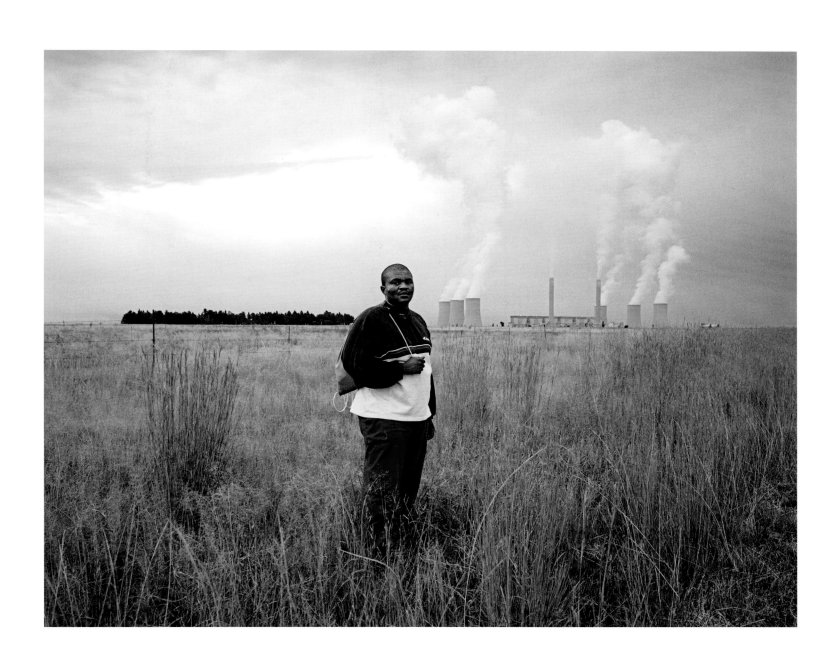

Johannes Ndila, Lethabo Power Station, Free State, 2011.

Decommissioned Pomfret Asbestos Mill, Pomfret, Northern Cape, 2012.

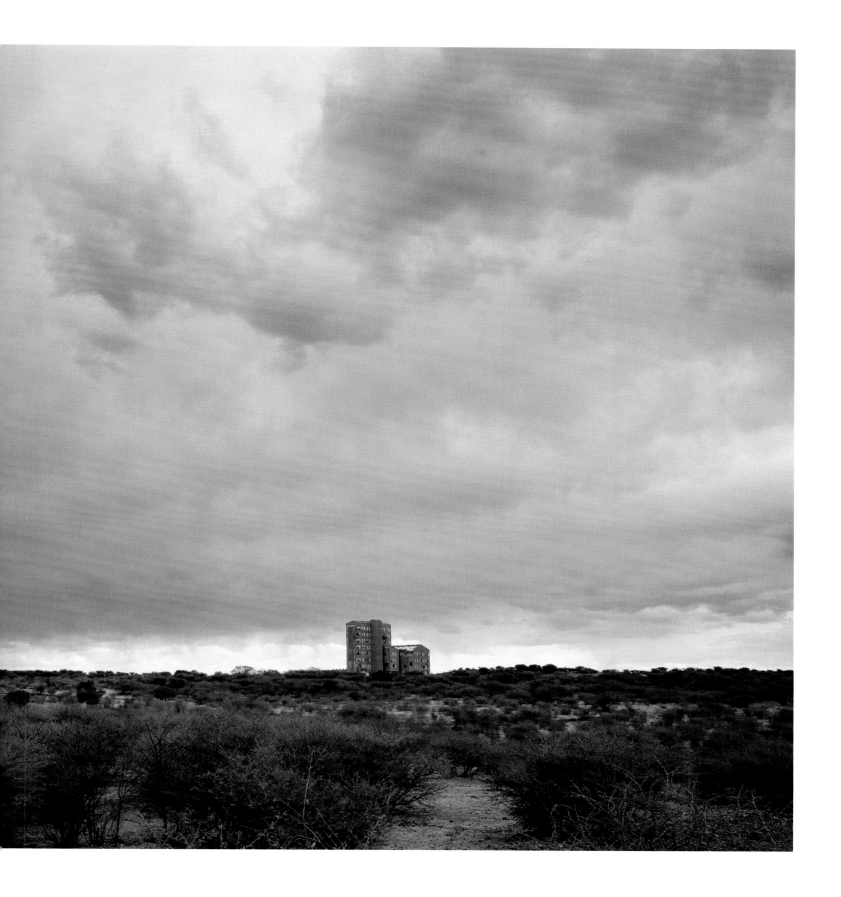

Ritual offering, Vaal River, Maccauvlei area, Free State, 2011.

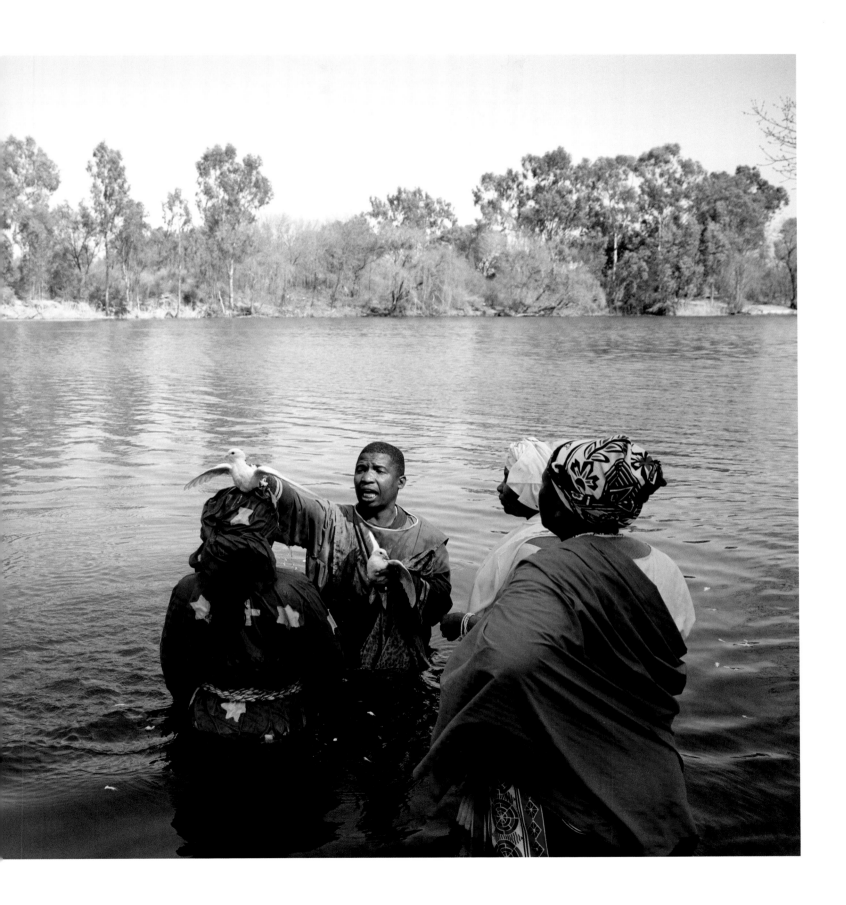

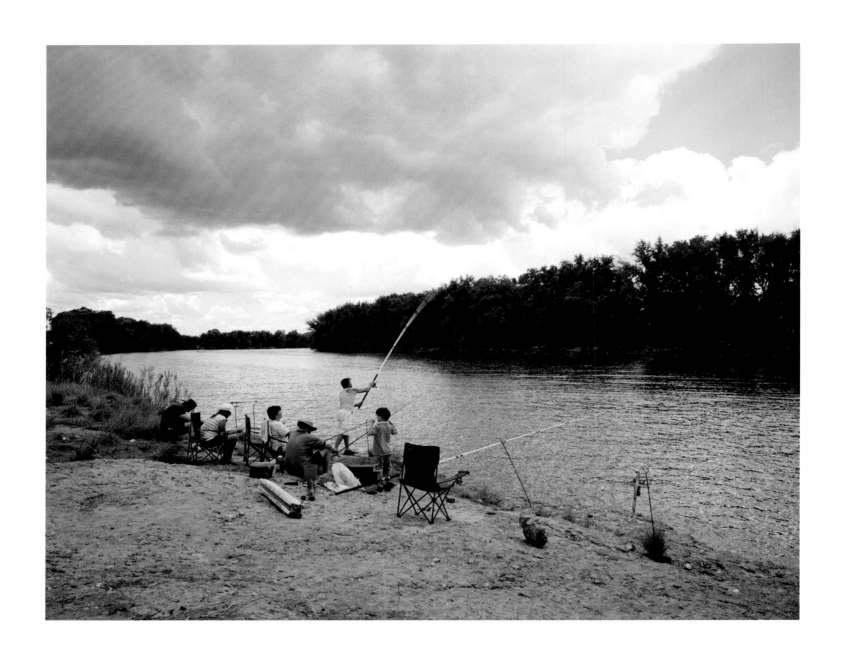

Fishing on the Vaal River, Vereeniging, Gauteng, 2011.

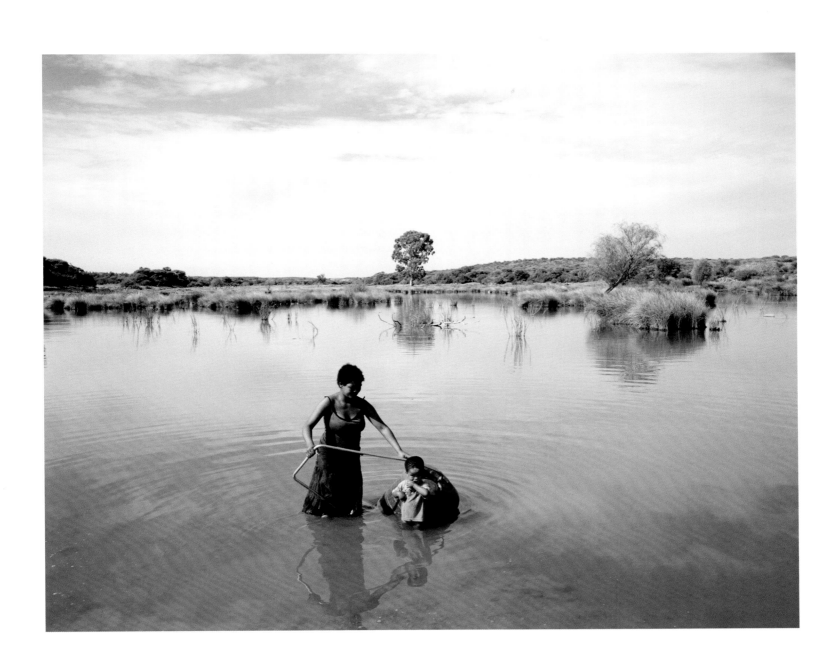

Collecting water, Gong Gong, Northern Cape, 2013.

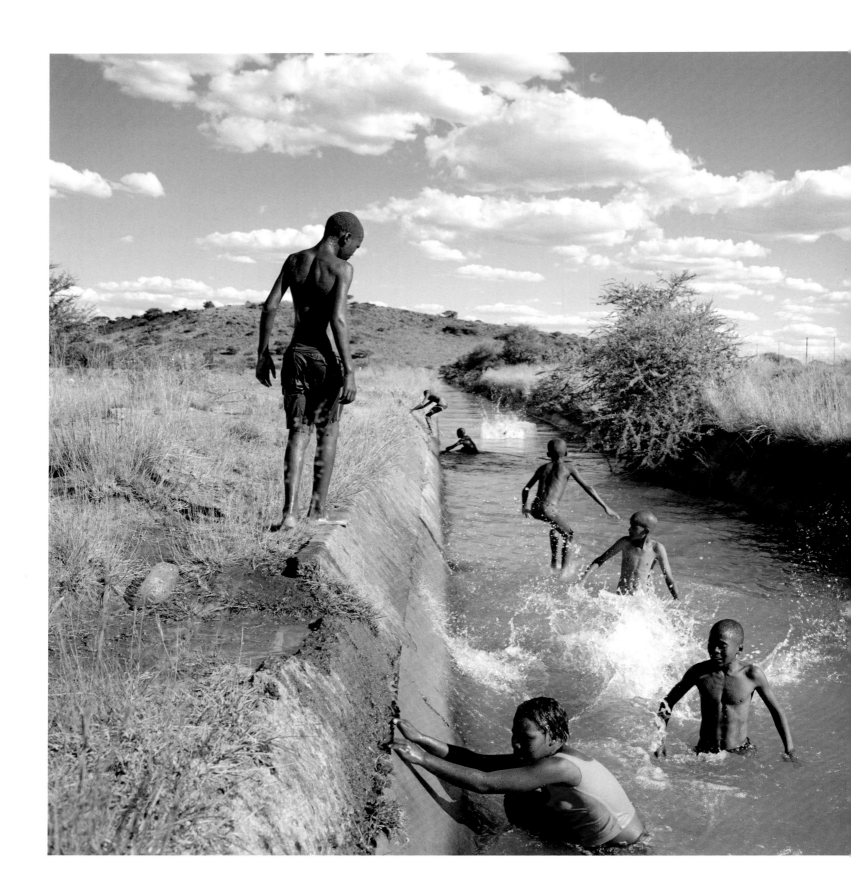

Swimming in the 'Long Sea', Diamanthoogte, Koffiefontein, Free State, 2013.

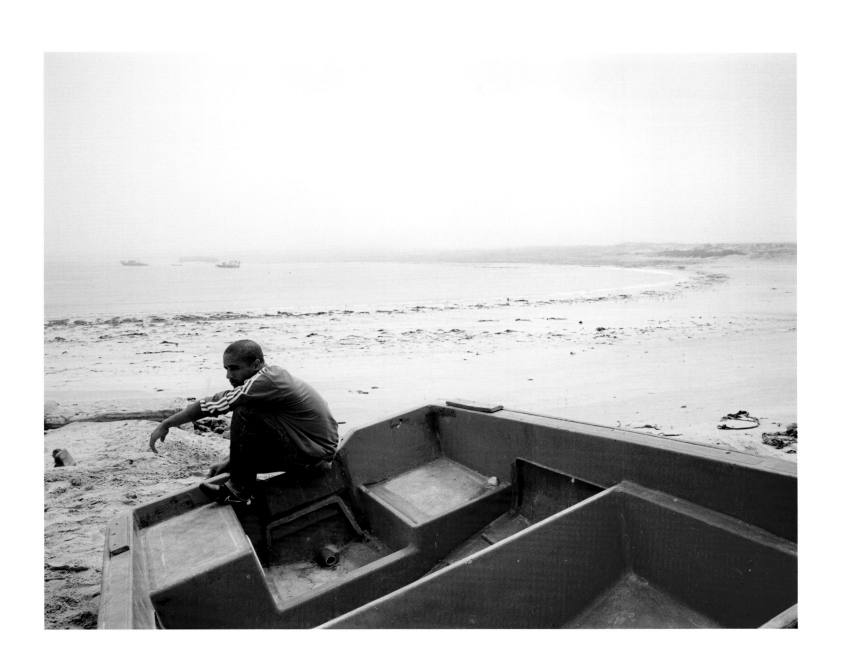

Malcolm Cloete, Hondeklip Bay, Northern Cape, 2012.

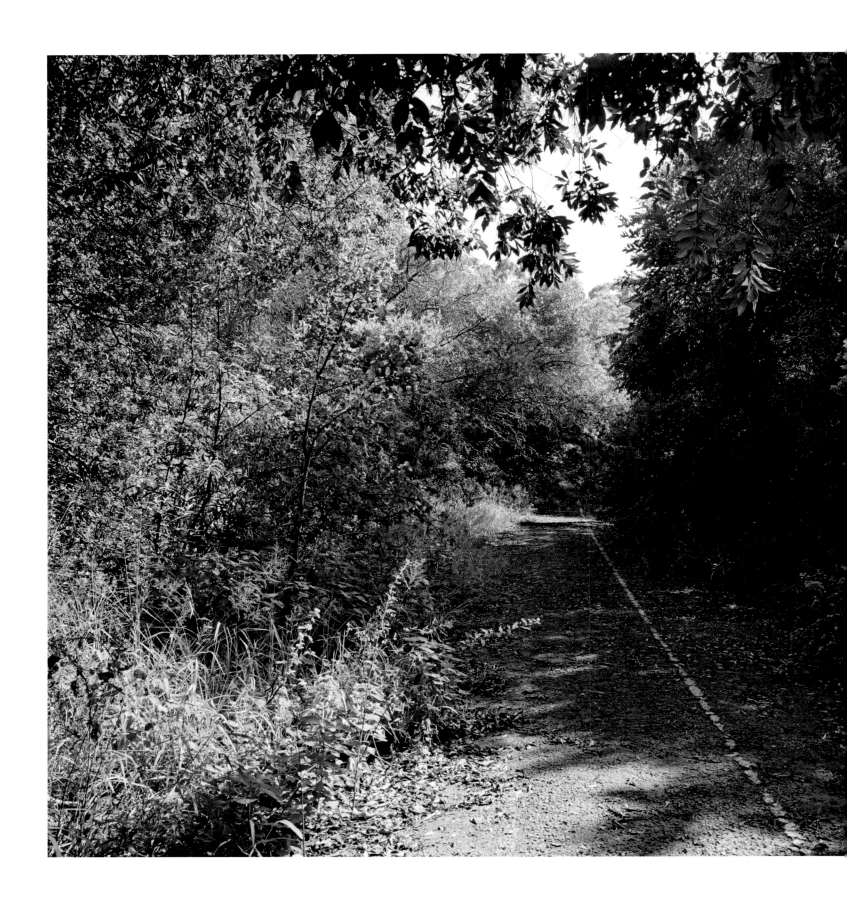

The old Muldersdrift Road, Melville Koppies, Johannesburg, Gauteng, 2013.

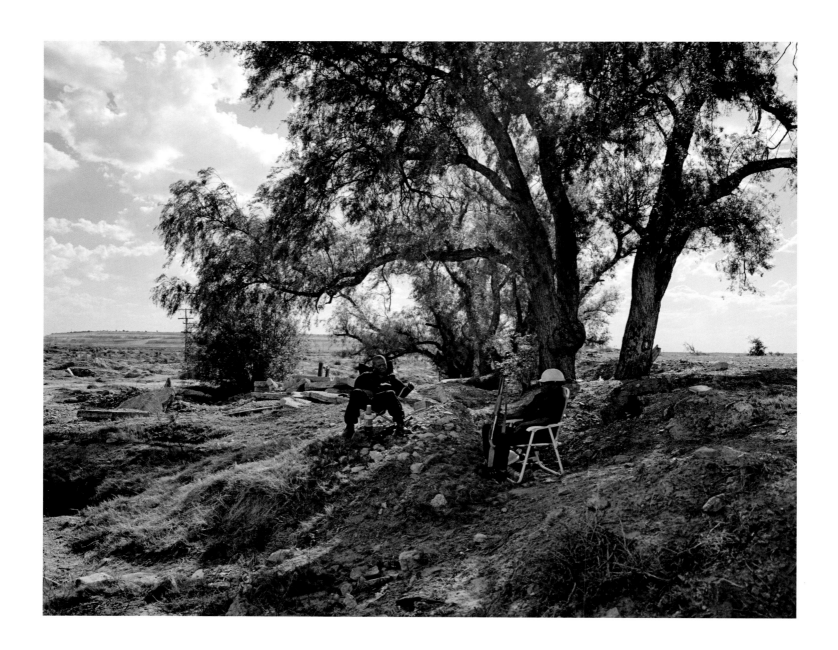

Paulus and Putsoane, security guards, disused St Helena 4 mine, Welkom, Free State, 2012.

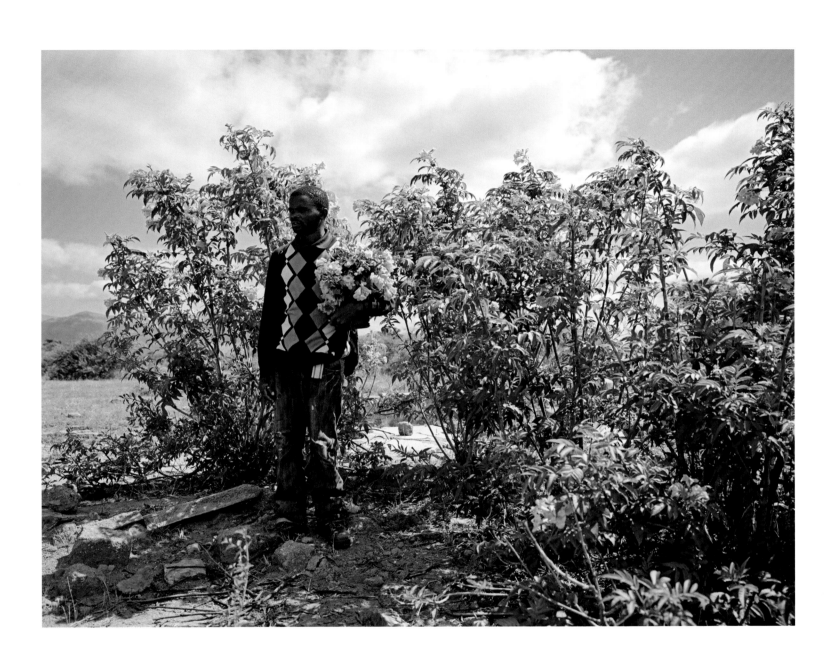

Jonas Mooka, Ga-Pila village, Limpopo, 2012.

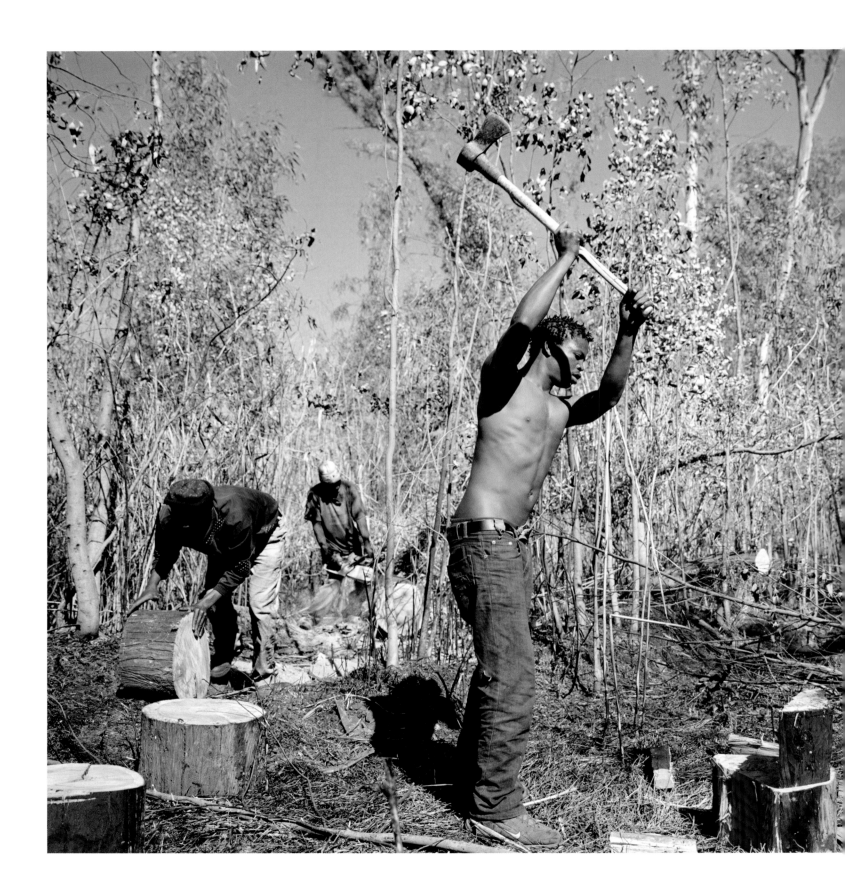

Moses Masuku, Springs, East Rand, Gauteng, 2011.

Mpho, commercial sex worker, Rheeder Park, Welkom, Free State, 2012.

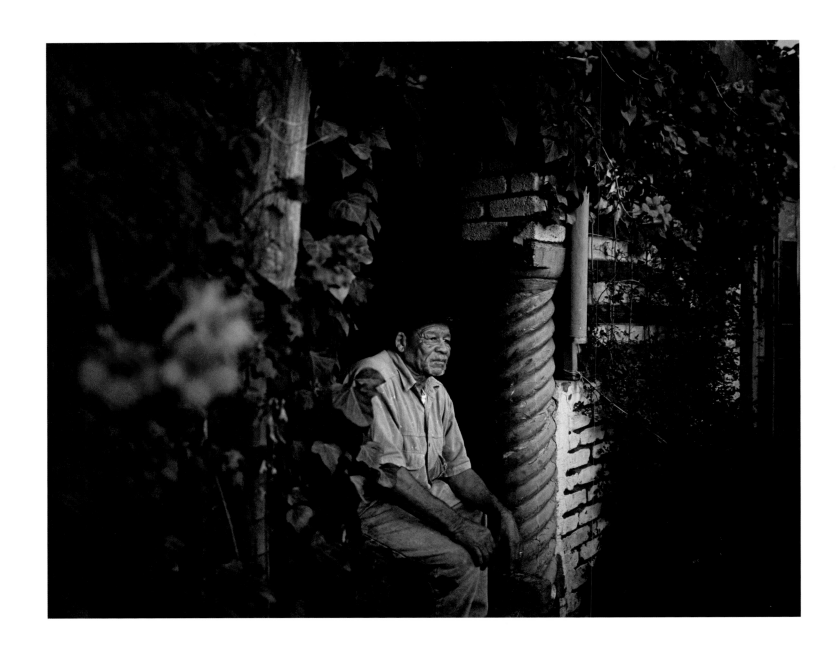

Willem Badenhorst, asbestosis victim, Wrenchville, Kuruman, Northern Cape, 2012.

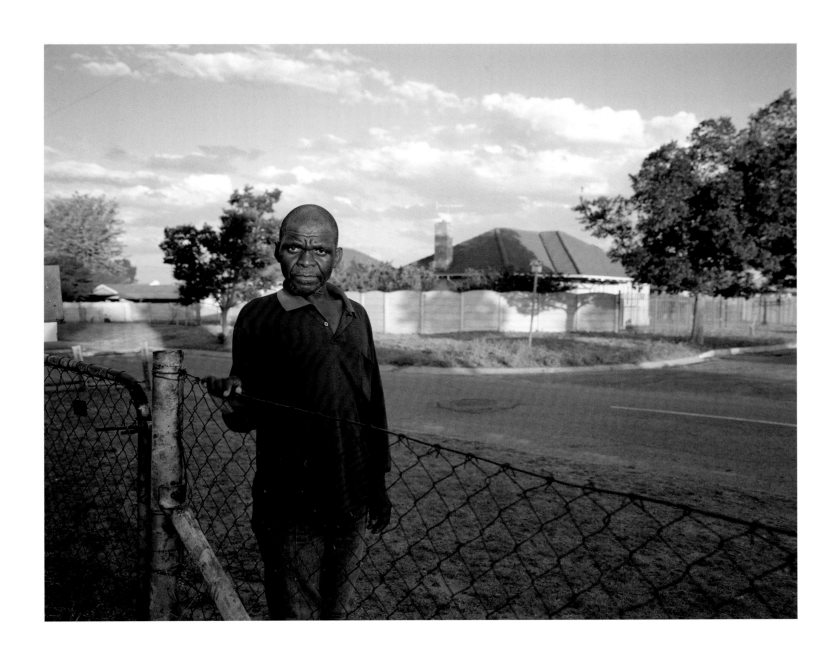

Zoyisile Mgqatsa, silicosis victim, Odendaalsrus, Welkom, Free State, 2012.

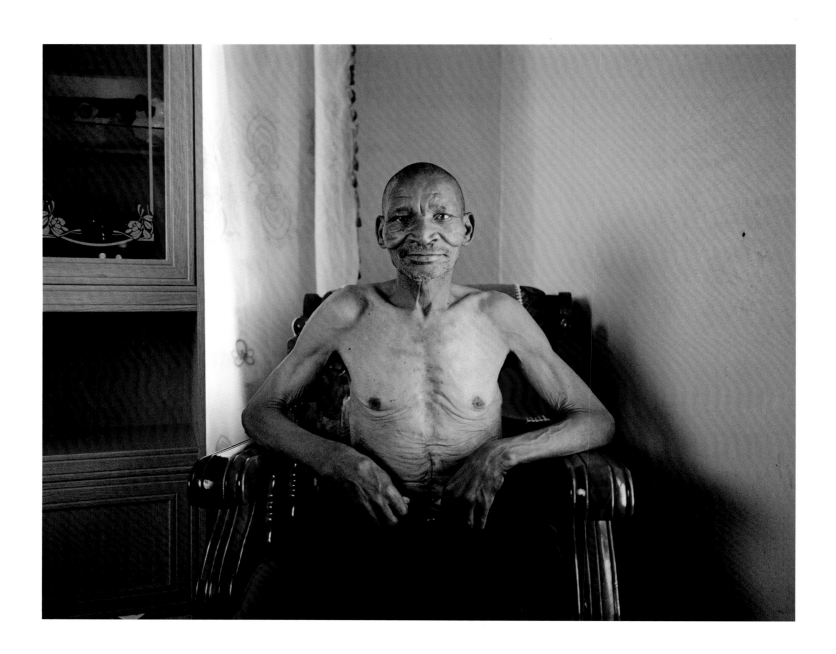

Molatlhegi Mongotleng, peritoneal mesothelioma victim, Garuele village, Northern Cape, 2012.

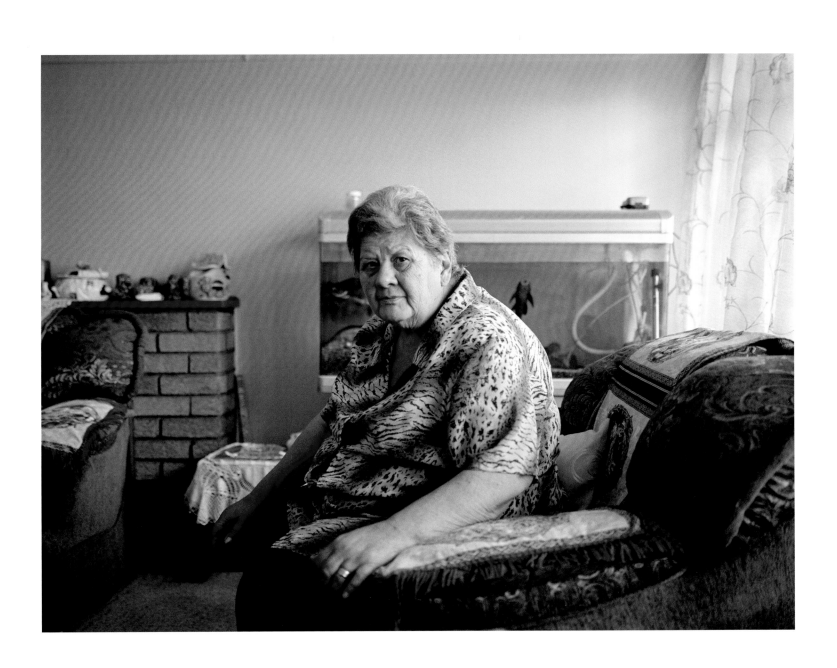

Marie Joubert, Komati, Mpumalanga, 2011.

Thokozani Sikhakhae, security guard, East Rand Proprietary Mine (ERPM)
Cason Shaft, Johannesburg, Gauteng, 2011.

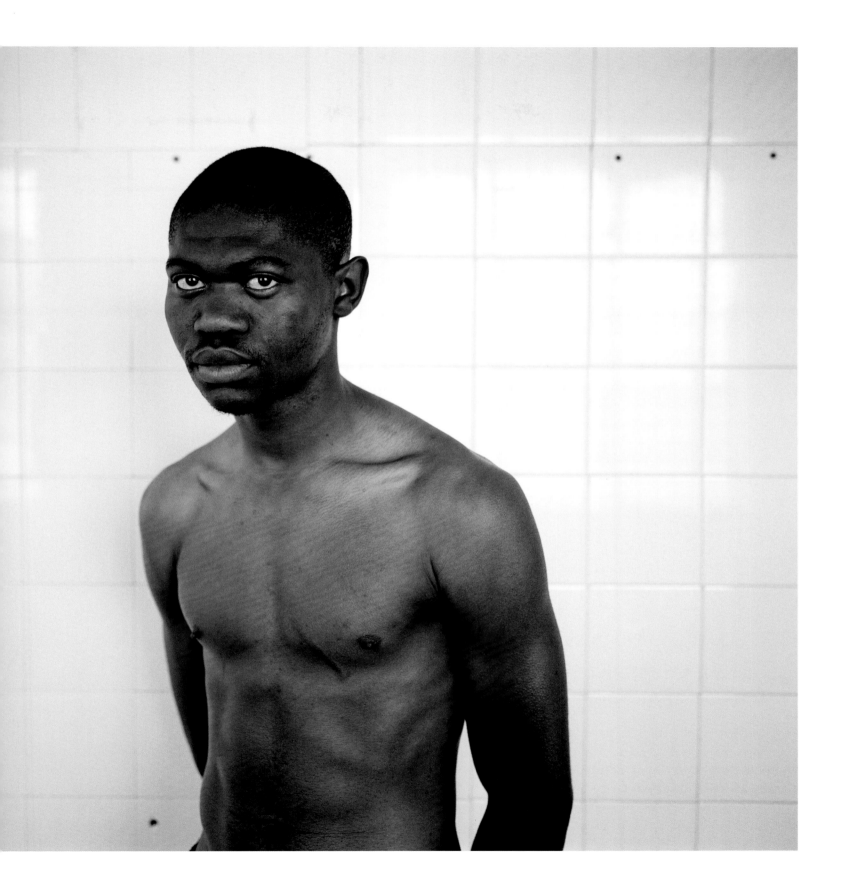

Sikhumbuzo Douglas Matsha, informal diamond digger, Hondeklip Bay, Northern Cape, 2013.

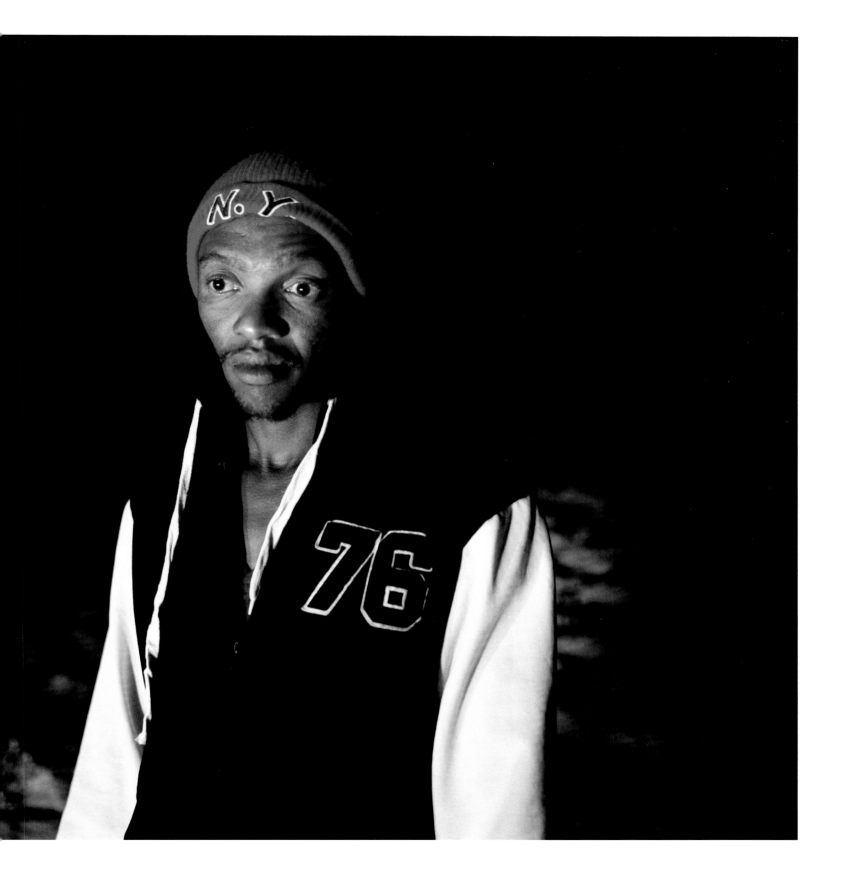

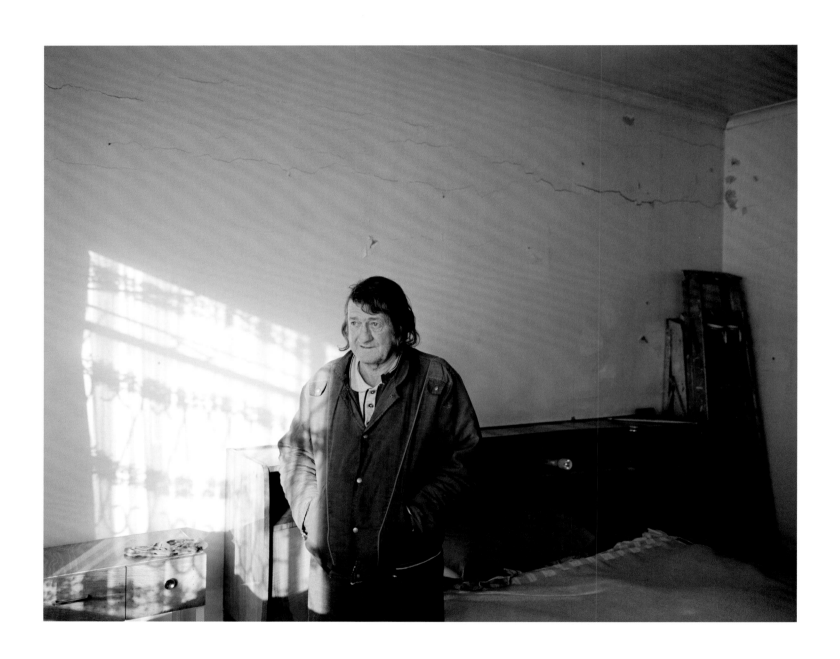

Chappy, De Bruin Park, Ermelo, Mpumalanga, 2011.

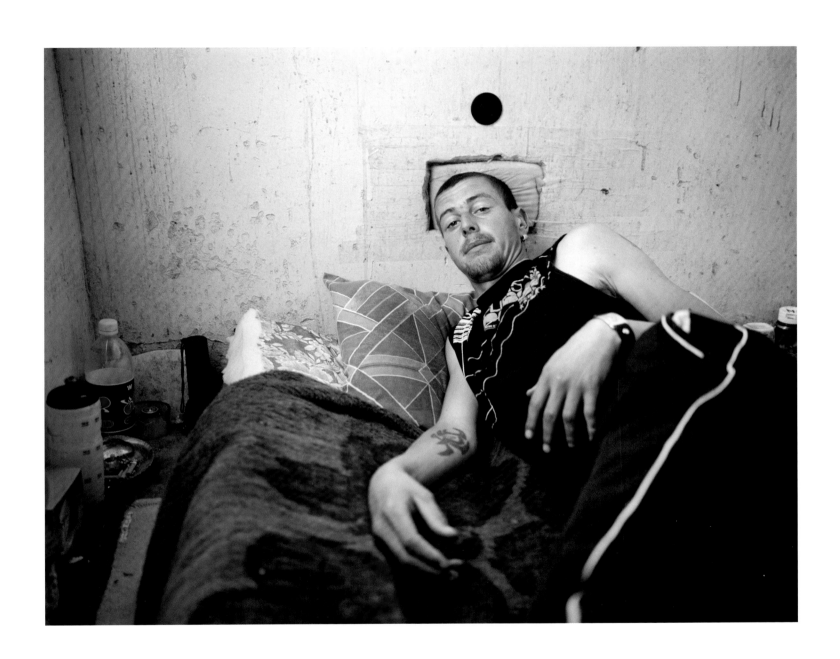

Willie, Cinderella Hostel, Boksburg, East Rand, Gauteng, 2011.

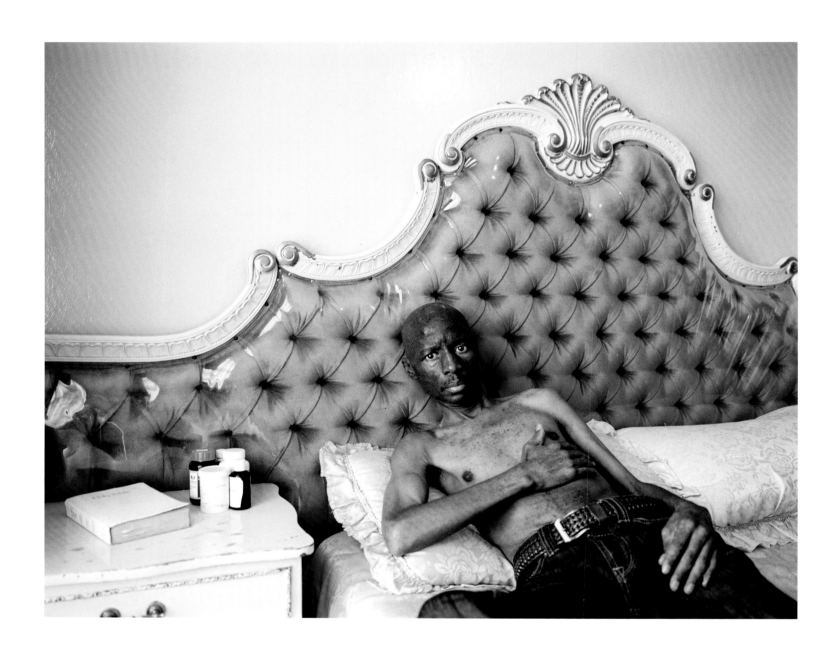

Mahlomola William Melato, silicosis victim, Oppenheimer Park, Tabong, Welkom, Free State, 2012.

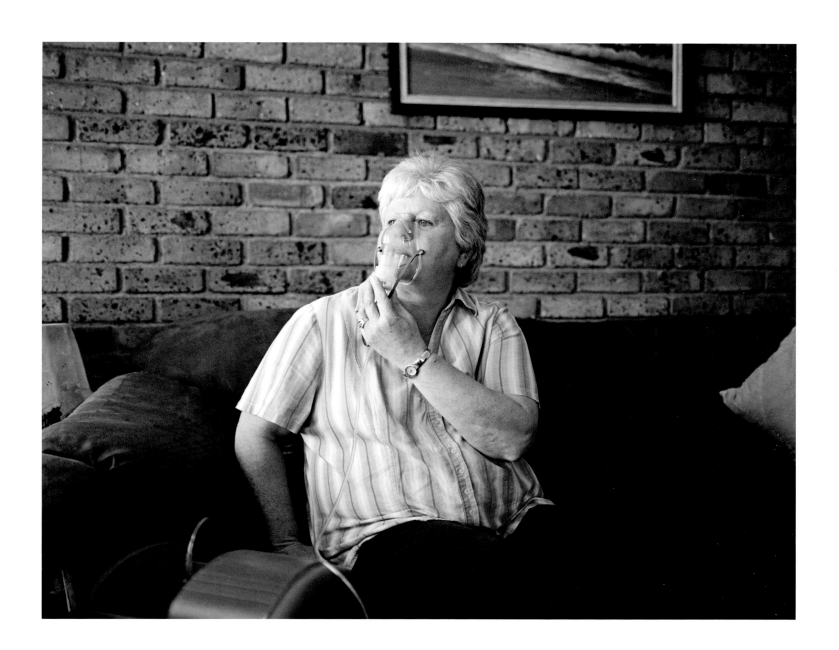

Anna Grobler,Emalahleni (Witbank), Mpumalanga, 2011.

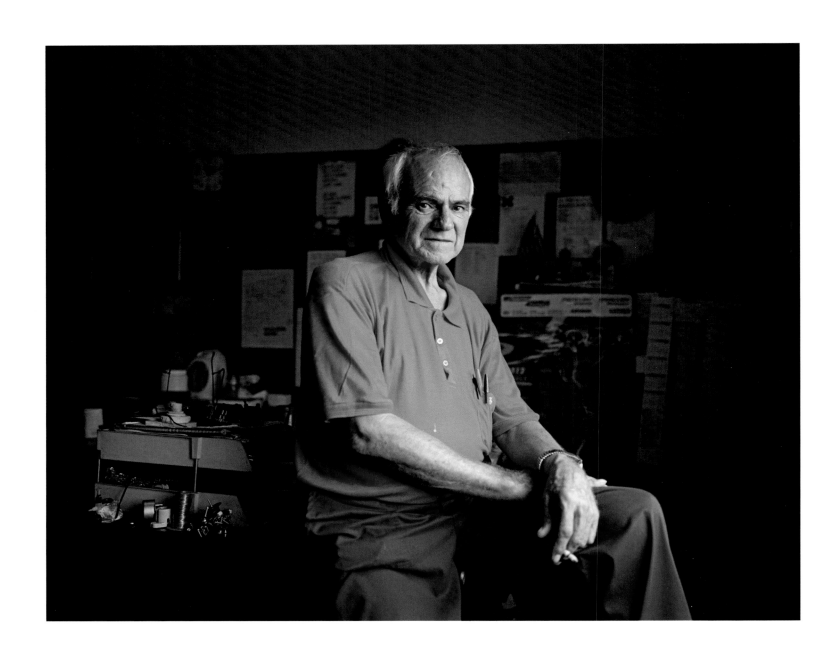

Thomas Richard McLean, Holly Country, Free State, 2013.

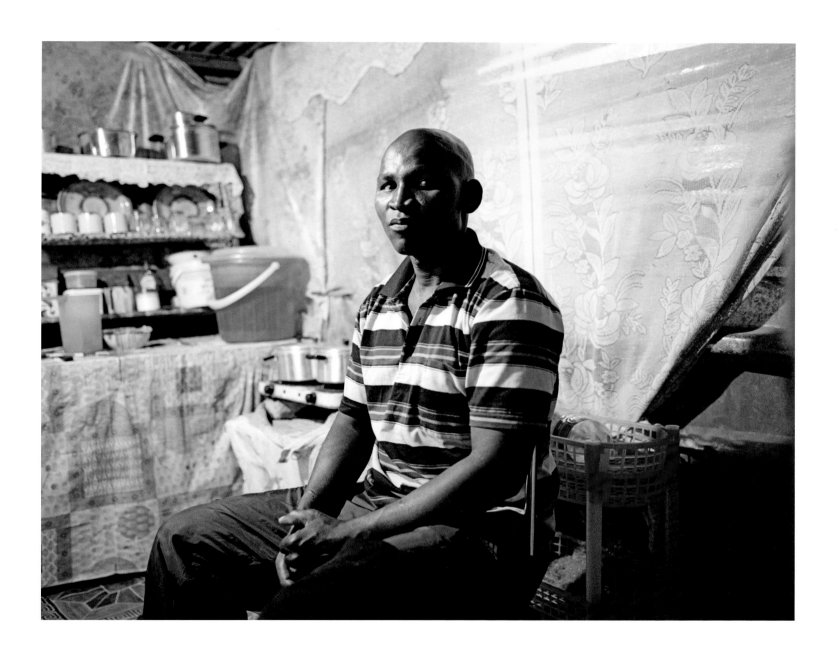

Zenzile Nxenge, Wonderkop, Marikana, North West, 2013.

Unmarked coffin, Sekuruwe village, Limpopo, 2012.

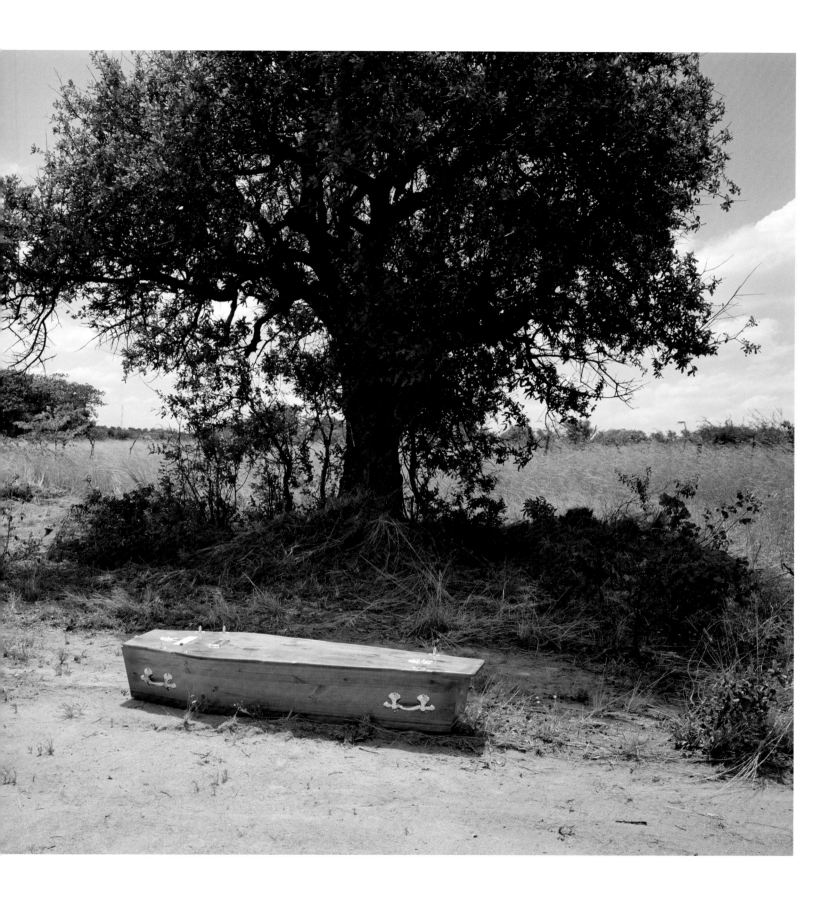

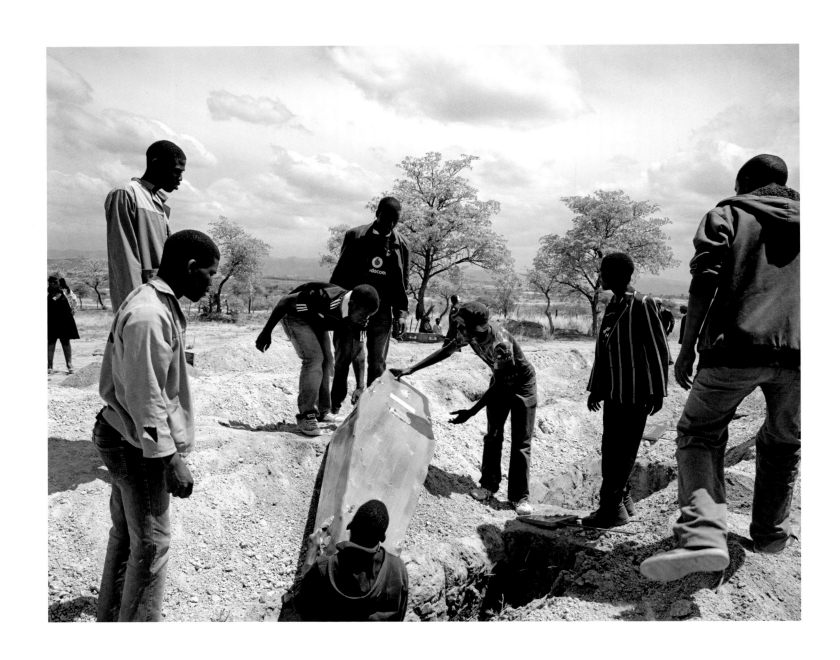

Reburial service, Sekuruwe village, Limpopo, 2012.

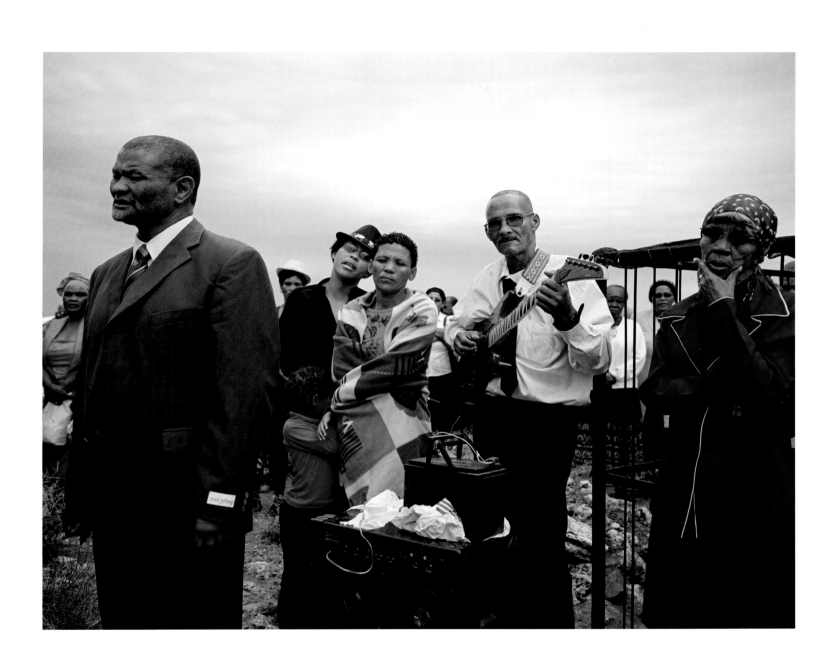

Funeral for Niklaas Badenhorst, Effel, Northern Cape, 2012.

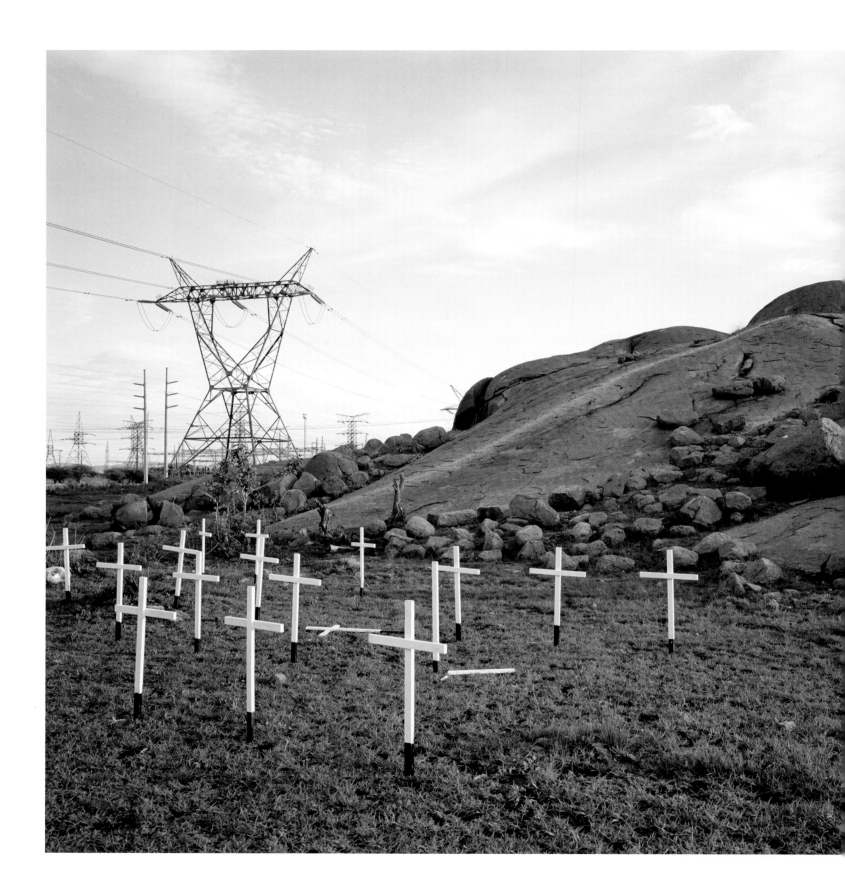

Memorial crosses, Wonderkop, Marikana, North West, 2012.

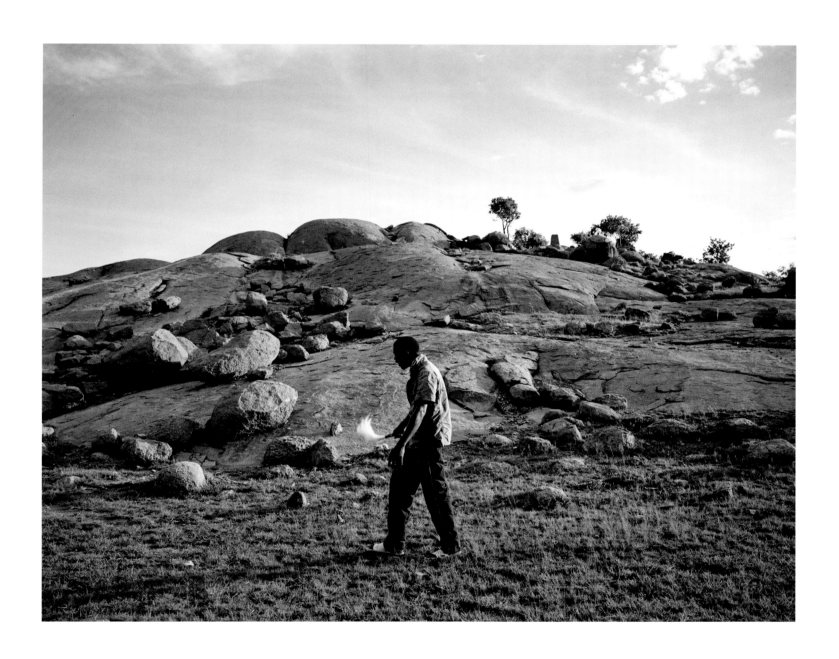

Mzelelo, Wonderkop, Marikana, North West, 2012.

Memorial gathering, Wonderkop, Marikana, North West, 2012.

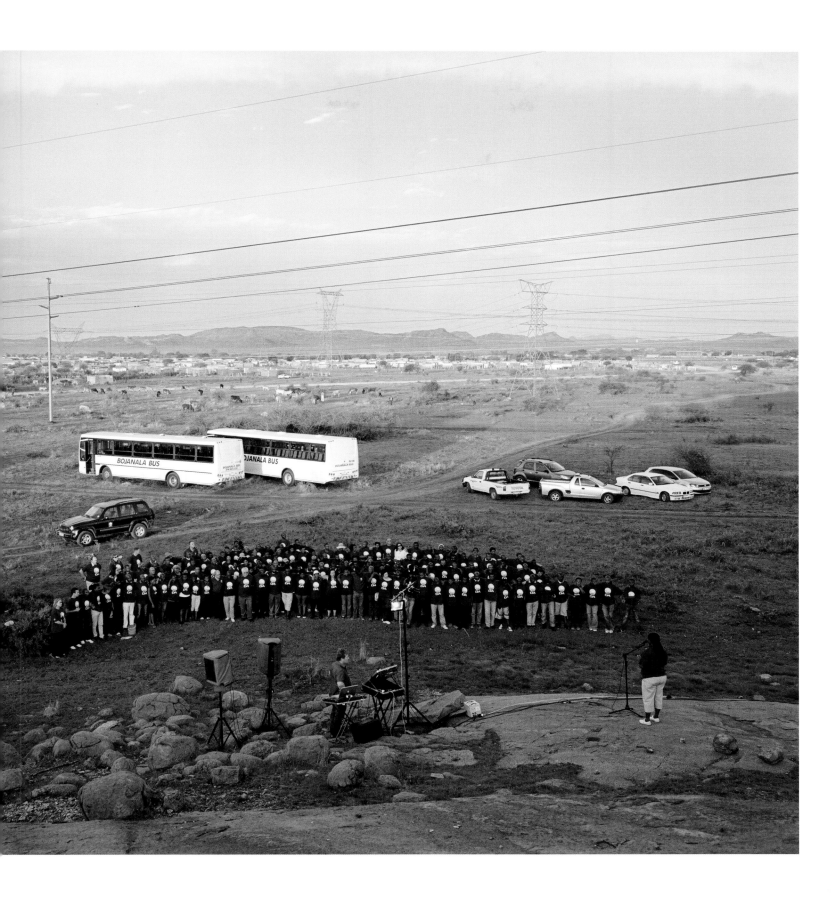

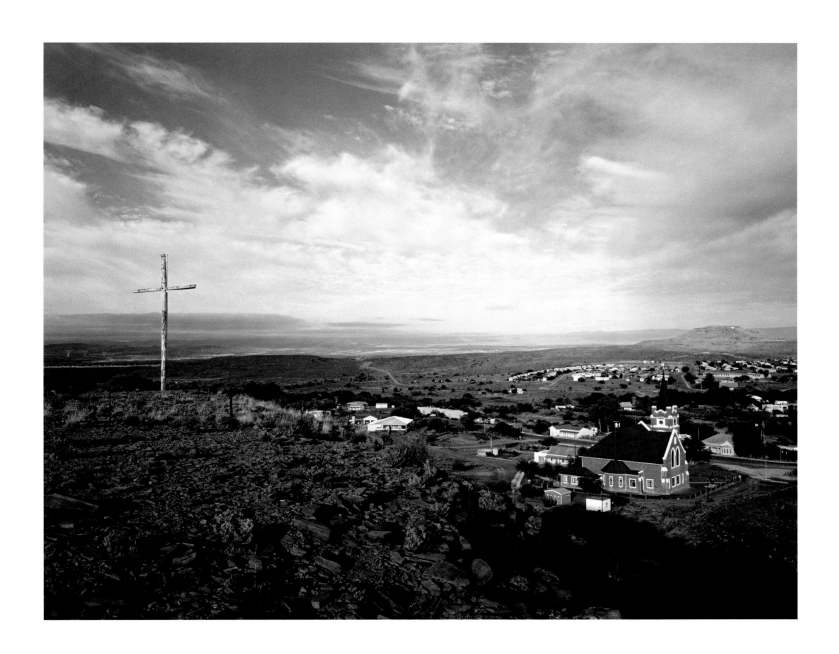

Merweville, Western Cape, 2013.

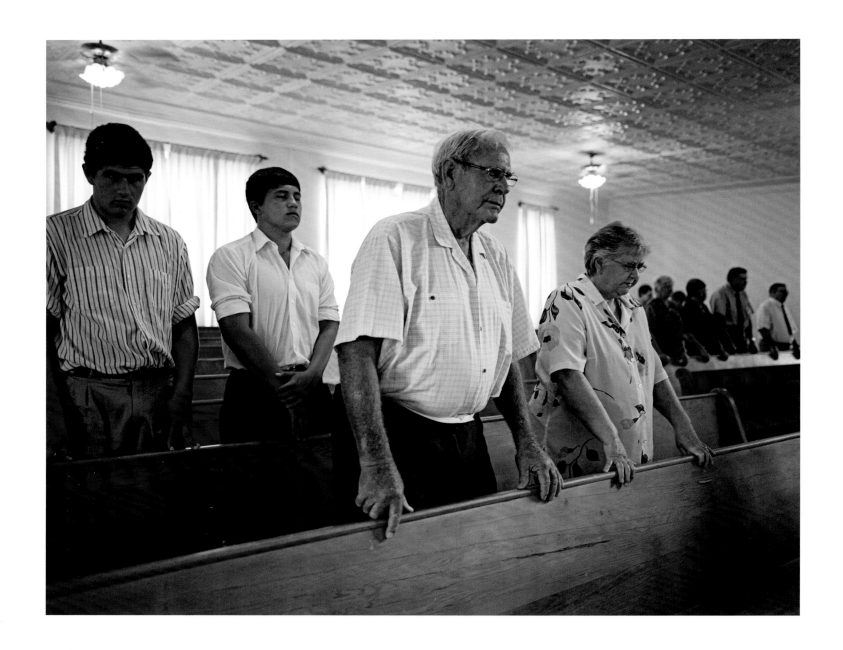

Sunday prayers, Dutch Reformed Church, Merweville, Western Cape, 2013.

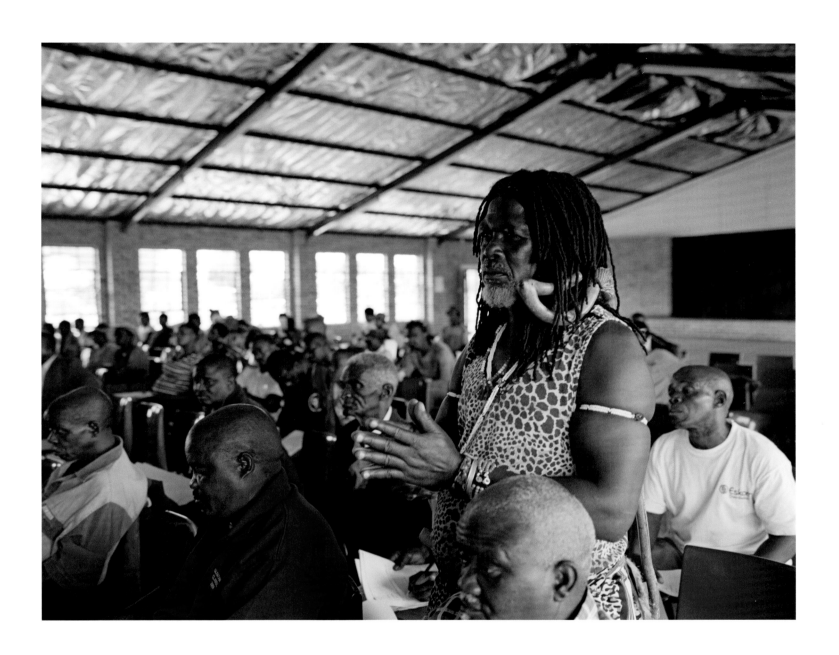

Community meeting, Motlhabe village, Pilanesberg, North West, 2012.

Alluvial diamond divers, Hondeklip Bay, Northern Cape, 2013.

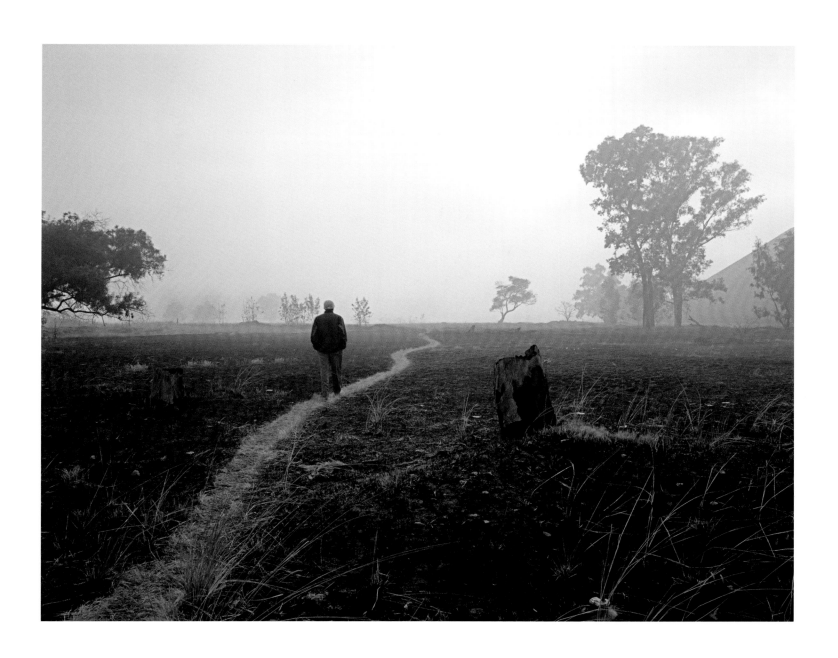

Decommissioned Delagoa Colliery, Emalahleni (Witbank), Mpumalanga, 2011.

EXTENDED CAPTIONS

BY ILAN GODFREY

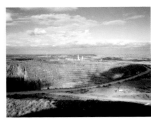

07

Palabora Copper Mine, Phalaborwa, Limpopo, 2013.
In the north-east of South Africa lies the mining town of Phalaborwa. It is the site of the largest man-made hole in Africa, whose magnitude is astounding; a scar on the earth that represents man's continual reliance on minerals and natural resources for economic development. The opencast Palabora Copper Mine was excavated over a period of 38 years. With a depth of 762 m and a diameter of 1846 m, it is visible from space, and is more than 230 m below sea level. Geologists have found that Phalaborwa was once the site of intense volcanic activity around 2000 million years ago. It created a vast area of about 20 square kilometres, rich in metals and minerals, called the Phalaborwa Igneous Complex. At the core of this complex, two central deposits, foskorite and carbonatite (which contains copper and iron), were thrust up by a volcanic eruption and outcropped at what was once Loole Kop, today the site of the Palabora opencast mine. As the area is rich in magnetite, it provided early Iron Age settlers with all the iron ore they needed for smelting. It is estimated that over 10,000 tons of rock containing various ore deposits were removed from the hill over a period reaching as far back as AD 400, before the start of current mining activities.

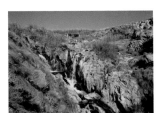

18–9

Tweelopie Spruit, Krugersdorp Game Reserve, Gauteng, 2012.
In late August 2002 acid mine water reached the surface from deep underground in the West Rand of Johannesburg, decanting from the disused gold mine shafts that make up the West Rand Mining Basin. It flowed into streams, rivers and lakes with devastating consequences, and poisoned everything in its path. Aquatic biota were destroyed and soil became polluted. Today, Tweelopie Spruit is a lifeless body of water now classified as a high acute toxic river system. Its course is far-reaching, affecting the Krugersdorp Game Reserve and the Cradle of Humankind World Heritage Site, and inevitably flowing into major river sources including the Limpopo. No provision has been made to rehabilitate the degraded river systems and compensate the communities that rely on these tributaries for agriculture and drinking water.

20

Eroded soil and sulphate deposits, Emalahleni (Witbank), Mpumalanga, 2011.
Acid mine drainage contains elevated levels of sulphate. Salt deposits are formed when acid mine drainage precipitates, leaving the impacted area with a thick white crust. Neutralised acid mine water contains sulphate levels of 2500 mg per litre, yet the environment is only able to sustain water with 100 mg per litre of sulphate.

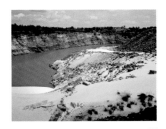

21

West Wits Pit, West Rand, Krugersdorp, Gauteng, 2012.
The man-made cavity known as West Wits Pit is the remnant of early mine workings on the Kimberley Reef, where gold deposits were exploited near the surface. Today, Mintails Ltd reclaims and processes the remaining gold from the mine dump tailings that dot the West Rand and uses the cavity for disposing of the remaining gold plant residue. Hazardous waste materials include processed slurry and discharged water from mining operations.

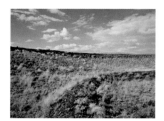

22

Rehabilitated Danielskuil Cape Blue Asbestos Mine (DCBA), Danielskuil, Northern Cape, 2012.
Eric Sekang, who worked on the mine as a 'crush clerk' from 1990 to 1992, before its closure, describes his experience there: 'During the mine's operation an average of 5000 people worked here. There was a hostel, so people came from all over the country to find work on the mines, including the Transkei and Lesotho. The risks of working on asbestos mines were not made known to us and health and safety regulations were not implemented. My family worked on the mine. When my sister went to the doctor, they diagnosed her with mesothelioma, and she later died.' Eric lost a further three sisters and his mother, the cause of whose deaths he could not prove; but he believes it was asbestosis. The responsibility for rehabilitating abandoned asbestos mines falls on the Department of Minerals and Energy. It is estimated that roughly half of the 121 identified abandoned mine and mill sites have been rehabilitated. Yet this does not include areas outside the derelict mine perimeters. Engela, a resident of Kuruman, showed me several sites where asbestos is clearly visible, including the local driving school and a neighbour's garden. Similar concern has been voiced by the community of Garuele village and surrounding areas where asbestos has been found in their backyards. Even though positive strides have been made in rehabilitating crucial areas of asbestos pollution, the ongoing dangers of environmental contamination continue to be a concern for communities living in the Northern Cape.

23

Unrehabilitated Bosrand Asbestos Mine, Northern Cape, 2012.
Bosrand Mine lies hidden from view on private farming land in the heart of the Kalahari landscape. It was once owned by Alec Whitehead's late father, who later died from asbestosis. Kuruman Cape Blue Asbestos (Pty) Ltd (KCB) bought the mine from his father, and it was finally taken over by Griqualand Exploration and Finance Company Ltd (Gefco). Bosrand is an unrehabilitated blue (crocidolite) asbestos mine. Of the three types of asbestos mined in South Africa, crocidolite is the most carcinogenic. The last operating asbestos mine in South Africa was Msauli in Kromdraai, which closed in 2002.

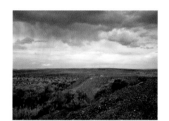

24

Acid mine drainage, East Rand Proprietary Mine, Johannesburg, Gauteng, 2011.
ERPM continues to produce gold from its Cason dump surface retreatment operation. Some 300,000 tons of underground ore are recycled each year, while 1.9 million tons of surface material are processed. Acid mine drainage is highly acidic water, usually containing high concentrations of metals, sulphides and salts. The major sources of acid mine drainage are drainage from underground mine shafts, runoff and discharge from open pits and mine waste dumps, tailings and ore stockpiles. These make up nearly 88 per cent of all waste produced in South Africa. Water drainage from abandoned underground mine shafts often decants into surface water systems, resulting in a host of environmental, social and economic problems.

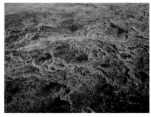

25

Acid mine drainage, Blesbokspruit, Emalahleni (Witbank), Mpumalanga, 2011.
Large coal deposits have given rise to widespread mining operations in the area. This has resulted in water systems being contaminated by acid mine drainage, which contains large quantities of metals.

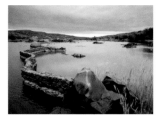

26

Breakwater, Vaal River, Good Hope Farm, Northern Cape, 2013.
This stone wall is all that remains of a once prosperous alluvial diamond digging on the Vaal River. The breakwater was built by Kenne de Kock on his farm in 1939 to channel water so as to aid digging. A team of 200 men pumped water out of the channel while blasting the rock.

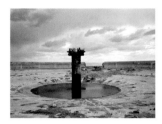

27

Thickener tank, St Helena Gold Mine, Welkom, Free State, 2012.
One of six thickener tanks at the disused metallurgical gold plant.

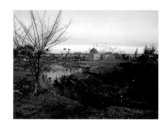

28–9

Sinkhole, Likazi, Emalahleni (Witbank), Mpumalanga, 2011.
This large sinkhole swallowed up several homes in Likazi informal settlement, which had been built above the abandoned Coronation Colliery. Miraculously, no one was hurt when the land collapsed. The sinkholes, some of which are up to 30 m deep, are not cordoned off and thus remain a constant danger to local residents, their homes and land.

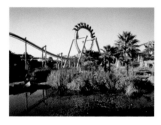

30

Gold Reef City Theme Park, Main Reef Road, Johannesburg, Gauteng, 2011.
Located on a disused gold mine, the park is themed around the gold rush on the Witwatersrand, and contains many buildings typical of a 19th-century mining town. Gold Reef City was built in the grounds of the former Crown Mines, one of the earliest and most important workings along the Main Reef of Johannesburg.

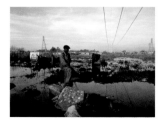

31

Jeffrey Ramiruti, Tudor Shaft, Mogale City, Krugersdorp, Johannesburg, Gauteng, 2011.
Jeffrey Ramiruti looks out over a stretch of water that has flooded a large part of the Tudor Shaft informal settlement. The settlement is built on top of mine tailings and is surrounded by land contaminated by mining activities and radioactive dumps, which expose the inhabitants to radiation and dust inhalation. Research gathered by Professor Chris Busby, a world expert in uranium products, has revealed that radiation levels on these dumps are 15 times higher than normal, similar to the exclusion zone of Chernobyl and Fukushima. It is estimated that, countrywide, 1.6 million people are living next to or on top of mine dumps. After eight years of lobbying, thousands of residents of Tudor Shaft are in the process of being relocated to safe land.

32–3

Riverlea mine dump, Main Reef Road, Johannesburg, Gauteng, 2011.
Monde, Puleng, Zizipho and Khuselo play on the Riverlea mine dump near their homes. Riverlea is a new low-cost housing development on the periphery of the dump, where the gold of the Witwatersrand Main Reef was first discovered in March 1886. For decades, gold miners have been extracting residual gold from the dumps. Today chemical methods are used to enable companies to 'remine' the dumps, in the process slowly changing the Johannesburg landscape once again. This has had a beneficial impact on the environment, as large mounds of sand are being flattened. For every metric tonne of solid waste in the dumps, approximately 0.3 grams of gold are found.

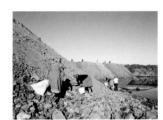

35

Informal digger, disused Daggafontein Gold Mine, Springs, Gauteng, 2011.
Daggafontein Gold Mine is a disused underground mine in Springs. Here an informal digger, or Zama-Zama, who preferred to remain anonymous, digs for gold-bearing soil on the abandoned dump. Surface diggers usually work in teams of two or three. They spend most of the day sifting several tons of sand into a finer form, removing the larger pieces of rock and stones. The finer sand is washed and the gold sediment is extracted through the addition of mercury. Mercury is a highly toxic substance, which is often handled without safety precautions. The work is labour-intensive and it can take several days before a digger accumulates one gram of gold, which is worth approximately R350.

36–7

Gathering dirty coal, disused Mashala Mine, Extension Six, Ermelo, Mpumalanga, 2011.
Women gather dirty coal from the disused Mashala Mine to heat their 'RDP' homes, situated 60 m from the community. In August 2011 a woman was buried alive while digging for coal. Mashala Mine began mining for coal right next to Douglas Dam, which provides Ermelo with drinking water. Under pressure from the community, the mine was closed and relocated. The land is in the process of being rehabilitated, but no attention has been given to the homes of residents damaged as the result of mining activity.

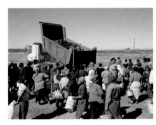

38

Elias, disused Daggafontein Mine, Springs, Gauteng, 2011.
Elias, an informal gold digger from Mozambique, heats the gold-bearing soil on an open fire. This is a rudimentary way of separating the remaining gold particles from the washed fine sand (also known as 'Mvovom').

39

Dirty coal collection, Thusi village, Ermelo, Mpumalanga, 2011.
The community of Thusi village gather together and wait for a supply of coal, which will keep them warm during the winter months and provide fuel for cooking. As hundreds of people congregate, I witness a frenzy and air of desperation as men, women and children with bags and buckets in hand begin collecting the best of the coal provided by the Golfview Mine. I later discovered that this was 'dirty coal', the waste left behind once the high-grade coal has been trucked off to buyers worldwide. Dirty coal is a major health risk, though the community of Thusi village know very little about its dangers.

Big Boy Mkhwanazi, a spokesman for the community, explains that Golfview and other mines attempt to earn the trust of the local community by providing 'dirty coal'. Yet their activities damage homes and pollute the natural water resources. Golfview Mining was found guilty on 17 October 2012 of various contraventions of the National Environmental Management Act of 1998 and the National Water Act of 1998 and was fined R4 million,

the largest penalty imposed to date for environmental offences in South Africa. Further offences included illegally mining a wetland, the diversion of water resources and inadequate pollution control. The estimated cost for the rehabilitation of the damaged wetland is between R50 and R100 million.

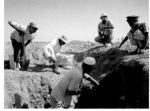

40

Nylon, Ismaeel, Rafiek, John and Loot, informal diamond diggers, Colville, Kimberley, Northern Cape, 2013.
Nylon Danze, Ismaeel Klaaste, Rafiek Goliath, John Panacas and Loot Sel are informal diamond diggers in Kimberley, who eke out a living on land that was once the site of the Colville Mine dumps, remnants of the 'Kimberley Hole' owned by De Beers. The men and women digging this land have had several confrontations with the police. 'De Beers send the police to catch us. They take our tools; we then have to start again to find a shovel, a pick, a wheelbarrow. They make us suffer. When we get tools the police come and take them away again.' The diggers say they simply want to make a living and feed their families. The feelings expressed by the community of Colville are clear: they feel robbed by the mine of what is rightfully theirs and neglected by the government. 'Our people were moved from the ground where the diamonds are, to here.'

In January 2013 I met William Wilson and Steven Smith to discuss their unsuccessful attempts to mine the Colville dumps legally. William says that as a young boy he played on the dumps that surrounded Colville. At that time the community was oblivious of the fact that the dumps contained diamond-rich waste. De Beers then laid claim to the dumps and in 1995 began to remove them. Inevitably this removal caused dust to blow through the area and affect the health of residents.

In 2002 De Beers approached the informal diggers, inviting them to attend a course in correct mining practices. Apprehensive at first, William, Steven and two other diggers decided to participate. They saw this as an opportunity to turn their lives around and provide for their community. Soon after the course was completed, they were invited by De Beers to register their company. Twelve years later, their Future Hope Diamond Company has still not yet received a licence to mine the remaining Colville dumps. After a lengthy battle to protect the remaining dumps, which William believes to be the inheritance of the community, most of the dumps have been removed by established mining companies. William feels cheated. 'We sold our furniture to get the money. The mine does not worry about the people; they just worry about the diamonds.'

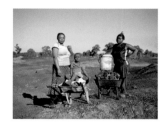

41

Sylvia, Angel and Setty, disused Coronation Colliery, Likazi, Emalahleni (Witbank), Mpumalanga, 2011.
Sylvia Mlimi, Angel Mona and Setty Mndawe with dirty coal collected on Coronation Colliery. Collecting coal is a daily necessity and is fraught with danger, especially when the ground collapses while digging. People from the Likazi informal settlement have died as a result.

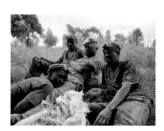

42

Linda, Daniel, Dumisani and Calvin, informal gold diggers, Roodepoort, Johannesburg, Gauteng, 2013.
Linda Ndlovu, Daniel Mandlo, Dumisani Mahlangu and Calvin Sibanda rest after a full night of work in a disused underground gold mine shaft. The men are highly skilled informal diggers with many years of experience. They are seen as 'brave men' and 'heroes' by the local community and are respected for their ability to pinpoint the gold-bearing deposits. They work together as a close team, carrying hessian bags filled with rubble and rock to the surface. They are commonly confronted by criminals, who beat them and rob them of clothes, mining equipment and money. They are all Zimbabweans by birth and now live in Matholesville township in Roodepoort, Johannesburg, surrounded by mine dumps and tailings.

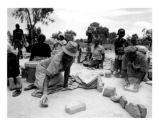

43

Precious Sibanda, Randfontein Road, Roodepoort, Johannesburg, Gauteng, 2013.
Precious Sibanda, 31, came from Zimbabwe to South Africa in December 2012. Precious is one of several hundred women responsible for grinding gold-bearing rock and mine tailings brought up from the disused underground mine shafts by informal gold diggers. She earns R120 for a full day of work to feed her two children. The work is highly dangerous. Precious and her children are exposed to inhaling silica dust, whose particles contain high levels of uranium, which causes internal radiation.

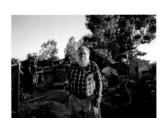

44–5

Sandile Dlamini, informal gold digger, Payneville, Springs, Gauteng, 2011.
Sandile Dlamini, 24, lives in the Payneville squatter camp in Springs. He used to work as a miner at Grootvlei Mine before it closed in 2010. Sandile showed me an unoperational ventilation shaft, 'No. 8', which is used by illegal miners as an access to Grootvlei Mine. From here shaft 'No. 4' is accessible, the main shaft where one can find gold of a higher value. Sandile says, 'Men have fallen to their death trying to climb into this shaft.' He adds, 'The conditions are unbearable and you can stay underground for six months to a year and only come up for food when it runs out.'

The men who organise the illegal mining are Zimbabweans and are known as 'Kingpins'. They take the diggers to the shaft and collect them once work is complete. Payment depends on how much gold is found, one gram of gold being worth about R350. The Kingpins supply the miners with food and water, for which they pay inflated amounts. Health and safety regulations are nonexistent, oxygen is limited and there is the constant risk of being caught for illegal mining or of the shafts collapsing. Life for these miners can often become violent, as they fight for the best digging positions.

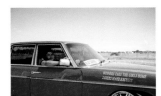

47

Jan Hendrik van Wyk, diamond delver and farmer, Windsorton, Northern Cape. 2013.
Jan Hendrik van Wyk was born in Upington and moved to Windsorton 45 years ago. Windsorton was founded in 1869 as a diggers' camp on the banks of the Vaal River. Once a thriving town where fortunes could be made, it now consists of a few remaining houses, which share the landscape with old rusting machinery and gravel dumps. Jan's life as a digger has not been one of great successes. He recalls that in 1981, after a long day of digging, he found a 37.6-carat diamond. Today a small community of diggers continues sifting the remaining land. Their search for the next big diamond becomes an obsession. With high overheads and rising diesel costs, they face incessant financial challenges. Windsorton today is filled with hardship due to lack of public amenities, petty crime, unemployment and alcohol abuse.

'King G', Transvaal Road, Kimberley, Northern Cape, 2012.
'King G' was born and grew up in Kimberley and now lives in the suburb of Homestead. There was a time when he made a living from buying and selling diamonds from informal diamond diggers in the area. He now earns his way entertaining crowds by spinning and drifting his classic Mercedes at the Monster Mob Raceway. A diamond digger from the Colville area says, 'The buyers come and see us, we cannot go to their houses, they check the diamond at the car, we are pleased we get something to eat and maybe buy groceries for the kids or something to wear. Our children went to school this morning without a little coffee or bread.'

48

49

Coal merchants, Slater coal depot,Emalahleni (Witbank), Mpumalanga, 2011.
During the winter months, merchants purchase coal from various collieries in Witbank, which is then sold to communities in the outer-lying townships.

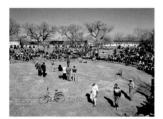

50

Private meeting, Grootvlei Mine, Springs, Gauteng, 2011.
A meeting was called to discuss the future of former employees of Grootvlei Mine in Springs, which was closed in 2010. Over 5000 miners from Lesotho, Swaziland, Mozambique and South Africa lost their jobs. They have been offered an opportunity to acquire other skills while the future of the mine is under negotiation. Grootvlei Mine is owned by Aurora Empowerment Systems, whose directors include Khulubuse Zuma, a nephew of President Jacob Zuma, and Zondwa Mandela, a grandson of former president Nelson Mandela. They have had very little involvement with the continuing problems at the mine. The mine has been stripped of most of its assets. The mine shafts have been damaged by the looting of scrap metal and it is estimated that it will cost the new owners around R300 million to put the mine back into operation.

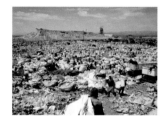

51

Sondela municipal dumping site, Rustenburg, North West, 2012.
On 15 January 2013 it was announced that Anglo American Platinum (Amplats) had made plans to restructure its operations in the face of rising production costs and poor platinum prices. This would result in the retrenchment of 14,000 employees, 13,000 of whom are located in the Rustenburg platinum belt. Among the shafts that would be placed under 'care and maintenance', i.e. indefinite closure, are Amplats Khuseleka Platinum Mines Khuseleka No. 1 shaft, which is situated on the periphery of Sondela municipal dumping site and Sondela informal settlement. The ANC and the unions have met this restructuring with fierce resistance. Negotiations are underway between the company and the unions, including the National Union of Mineworkers, the Association of Mineworkers and Construction Union, the National Union of Metalworkers of South Africa, and the United Association of South Africa.

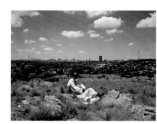

52-3

Prayer on Melville Koppies, Johannesburg, Gauteng, 2013.
Felix Ngwenya and Nkosana Ncube rest in the early afternoon sun on Melville Koppies overlooking the Witwatersrand Basin, where the world's largest known gold reserve is situated. They are part of the Twelve Apostles Church in Zimbabwe. Felix moved to Johannesburg in 1991 and Nkosana arrived in 2010. They have come to pray and fast from sunrise to sunset. Melville Koppies has become a sacred site for worship and prayer for several African religious groups. Felix says, 'It is a place where we can gather our thoughts, it is peaceful and helps us release stress.' Melville Koppies is also a site of historical importance where remains of an Iron Age community have been unearthed. The Koppies are a reminder of the indigenous landscape of the Witwatersrand and the ancestors of the present Tswana population, before the discovery of gold and the resulting development of Johannesburg.

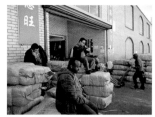

54–5

Dragon City, Main Reef Road, Johannesburg, Gauteng, 2011.
From Dragon City, also known as China Mart, huge shipments of Chinese imports make their way to South African pavement stalls and markets. Chinese people have been present in South Africa for centuries. In May 1904, the first batch of 10,000 Chinese labourers arrived to work on the Witwatersrand gold mines after the end of the South African (Anglo-Boer) War, when there was a shortage of labour. They continued to arrive for the next four years and by 1908 their numbers totalled nearly 100,000.

56

Pelou Mwepu-Kalonji, security guard, Dragon City, Main Reef Road, Johannesburg, Gauteng, 2011.
Pelou Mwepu-Kalonji, 29, comes from the Democratic Republic of the Congo, where 'I had no job and was concerned for my safety … there is no democracy in my country.' He has lived in South Africa for three years. Main Reef Road, once known as Witwatersrand Main Road, can be dated back to 1898, when construction began on this major artery. It was intended to link all the mining towns on the Witwatersrand and was used for the transportation of supplies to the mines. The Reef extends for about 45 kilometres from Boksburg to Krugersdorp.

57

S and M Supermarket and General Dealers, Meyerton, Gauteng, 2011.
In addition to the Witwatersrand, gold was also discovered in 'Black Reef', which runs along the banks of the Klip River, a tributary of the Vaal. The town of Meyerton was officially proclaimed on 6 June 1891. It now has a population of 12,000.

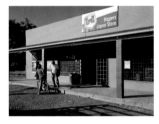

58–9

Diggers Liquor Store, Jagersfontein, Free State, 2013.
The Jagersfontein open pit was dug by hand and is said to be the world's largest vertical hand-dug open hole. Since the mine's closure in 1971 the town has seen a gradual decline, exacerbated by municipal mismanagement after the end of apartheid. In view of the inefficient mining methods of the past, it is believed that large quantities of diamonds remain to be recovered. As a result a new company has been set up to recover diamonds from surface dumps at the former Jagersfontein Mine. Local residents hope that the arrival of the new company will bring job opportunities and sustainable infrastructure to the town.

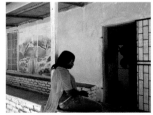

60

Nana's hair salon, Jagersfontein, Free State, 2013.
Nana, which means 'Queen', is originally from Ghana. She came to South Africa to make a better life for herself. She does not like the big city, so she decided to move to Jagersfontein, where she has lived for two years and runs a hairdressing salon. Situated in the Free State province, the town came to prominence when two of the largest diamonds ever found were discovered here: the 972-carat Excelsior diamond and the 637-carat Reitz diamond, later renamed the Jubilee diamond to honour the sixtieth anniversary of the coronation of Queen Victoria in 1897.

61

Piet Maans, janitor, Shell Ultra City Service Station, Laingsburg, Western Cape, 2013.
Piet Maans has worked for the past 17 years as a toilet cleaner at the Shell Ultra City in Laingsburg. He was born here and lives in Goldenerville location with his wife and two children. I asked him if he was aware of shale gas exploration, more commonly known as fracking, and if it would benefit the local community. He believes they will not benefit from the drilling. 'We will not get jobs in those places; they will bring their own people.' He was the only person who was aware of shale gas exploration when I asked several residents from Goldenerville location. On 15 February 2013 I attended a meeting in the town of concerned farmers and municipality officials to discuss fracking. One of the main issues raised was that the operation of the 24 wells required for fracking purposes would exhaust the annual water supply of the Beaufort West municipality.

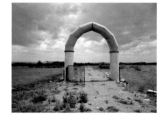

62–3

Disused entrance, Marikana, Rustenburg, North West, 2012.
A disused entrance, with the Lonmin Platinum 4B Incline on the horizon.

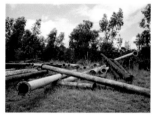

64–5

Toxic radioactive steel pipes, West Rand, Krugersdorp, Gauteng, 2012.
These steel pipes are filled with iron hydroxide and other radioactive metals, including lead, aluminium, manganese, copper, cobalt, arsenic, nickel, zinc and uranium. An average of 30 million litres of neutralised acid mine water are pumped through pipes like these every day, into the Tweelopie Spruit, a tributary of the Limpopo RIver.

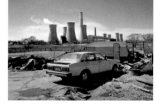

66

Komati Power Station, Komati, Mpumalanga, 2011.
Komati Power Station between Middelburg and Bethal in Mpumalanga is a coal-fired plant operated by Eskom. The Mpumalanga province has been declared an air quality priority area. Currently this province has some of the worst air quality in the world, largely because of coal-mining activities, uncontrollable underground fires and power stations burning coal. The good-quality coal is exported, leaving the poorer quality to be burned by South Africa's coal-fired power stations, adding to the country's carbon footprint and dirty emissions.

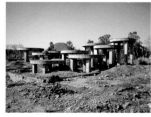

67

Leach tank foundations, disused Daggafontein Mine, Springs, Gauteng, 2011.
These concrete foundations once supported the leach tanks at the disused metallurgical gold plant of Daggafontein Mine.

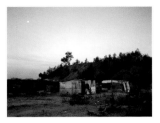

68

Decommissioned Coronation Colliery, Likazi, Emalahleni (Witbank), Mpumalanga, 2011.
Likazi informal settlement is built on top of Coronation Colliery in the Witbank area. In recent decades, a number of studies have drawn attention to the higher than normal rates of respiratory disease and stunted growth in children in the Emalahleni area. This is the result of their being exposed to coal smoke from domestic fires for cooking and heating.

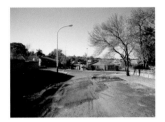

69

Acid mine water seepage, Jackaroo Park, Emalahleni (Witbank), Mpumalanga, 2011.
The residential area of Jackaroo Park is situated on the eastern outskirts of Emalahleni (Witbank). To the north the railway that connects Emalahleni and Middelburg separates the suburb from coal mines in the area. Henryette Jacobs, a spokesperson for the community, has expressed concern about the local colliery. She says, 'Our bore-hole water is polluted, the municipal water is brown and now we have to purchase our drinking water.' Acidic salt-laden water can be seen seeping into gardens and onto roads. Local residents claim this is acid mine drainage. Water-testing laboratories have confirmed that the water is unsafe and a health concern. Henryette says, 'Everyone talks about when acid mine drainage will seep up into Johannesburg's streets. Well, here it is happening now.'

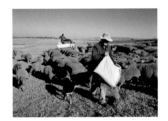

70–1

Johan Celliss, Ermelo, Mpumalanga, 2011.
Johan Celliss has lived on his family's farm in Ermelo for 55 years. He is surrounded by a fragile ecosystem consisting of natural wetland as well as the main catchment area of fresh water for four waterways in South Africa. Johan has been entangled in an ongoing battle to protect his land from the ever-encroaching Mooiplaas Mine, which wants to extend its operations, as coal deposits have been found on his property. Johan says, 'The problem is farmers do not know their rights. A group of people approach you claiming they have prospecting rights and begin drilling holes on your farm. I am not against development, but this is rape of the environment. If mining continues, they will pollute the water for generations to come.' For now Johan has managed to keep the mine at bay. He says, 'Things have gone silent, but there are rumours they are going ahead. There is a fight looming.'

Andries Janse van Rensburg has already lost his farm to coal mining in the Ermelo area. He specialised in the production of eggs, maize and soya beans. With dynamite explosions occurring every second day, egg production fell and coal dust prevented the pollination of soya and maize, while the damage to the grass ground down the teeth of livestock, causing starvation. 'The mining slowly crept closer to my house. There were soil heaps 18.6 m from my front door. They used to mine through the night when they were not supposed to; they had no licence for mining at night. They mined 24/7 without a water licence. Are they above the law? They told me if your chequebook is not as thick as ours do not pick a fight with us, because you are going to lose. They come to the farm and intimidate us, saying if we do not work with them, they will evict us. We are the food producers of South Africa. If all the farmers stop farming, what are we going to eat? We cannot eat coal.' Today Andries lives in the town of Ermelo.

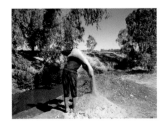

72

Informal gold digger, disused Western Holdings Mine, Welkom, Free State, 2012.
Gold-bearing gravel is unloaded near a polluted sewerage canal, adjacent to the disused Western Holdings Mine, Shaft No. 5. Once unloaded, the gravel will be washed in order to find the gold-bearing sediment. The men and women who dig here tell me they are often threatened by the police: 'They say we are out of the law and must give them money or cold drink.'

Lerato is 24 and comes from Bloemfontein. He is responsible for the washing of the gravel. He has been arrested for his informal digging activities in the past and as a result spent one year in Virginia prison. 'I am just trying to survive. I have a matric and am in the process of applying to the South African Defence Force.'

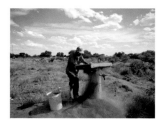

73

Oupa Koos, informal diamond digger, Floors, Kimberley, Northern Cape, 2013.
Oupa Koos, 57, shakes a rudimentary rocker to sift gravel in search of diamonds. Born in Kimberley, he has worked as an informal diamond digger for most of his life. He lives in the township of Floors, in Kimberley.

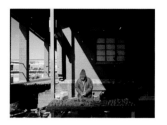

74–5

Daniel Ndou, Rand Leases Mining Hostel, Main Reef Road, Roodepoort, Gauteng, 2011.
Daniel Ndou is 58 and runs a stall selling fruit, vegetables, sweets and cigarettes. He comes to the hostel every morning to sell his goods. He lives in Marie Louise informal settlement on the periphery of the Rand Gold Mine Lease. After changing hands several times over the years, the mine ceased operations in the 1990s. The hostel remains inhabited by local residents.

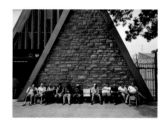

76

Ikusasa Community Development Centre, Von Brandis Street, Krugersdorp, West Rand, Gauteng, 2012.
This centre provides hot meals to the homeless living in Krugersdorp and Coronation Park. Coronation Park is a predominantly white informal settlement. Once a thriving mining town, it played an integral part in the development of the area. Today it reveals the consequences of the unplanned closure of the mines.

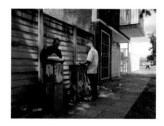

77

Lionel and Hans, Krugersdorp, West Rand, Gauteng, 2012.
Lionel Bates and Hans Viljoen eat a hot meal provided by the local church. They live in Coronation Park, once a holiday caravan park and now an informal settlement for impoverished whites. Hans, a former member of the Afrikaner Weerstandsbeweging (AWB) and a boilermaker at Cooke 3 Gold Mine in Randfontein, is now unemployed. Hans showed me the three sevens tattooed on his forearm, the emblem of the AWB. 'I gave my life to the AWB movement, but I have come to realise its ideas are flawed. Where are they now to help me?' Hans worked on the mines most of his life, but he found it difficult to hold down a job during the political transition in South Africa. Hans believes South Africa will experience the same fate as Rhodesia (now Zimbabwe).

78–9

Koot and Daniel Fourie, asbestos victims, Northern Cape, 2012.
Koot Fourie and his brother Daniel Jacobus, nicknamed 'Kat', have both worked for various asbestos mines for most of their lives. They were employed as contractors mixing white and blue asbestos with cement to make bricks for building houses. They also provided maintenance work on the asbestos mines across the Northern Cape. Daniel began working with asbestos when he was 17. 'We did not know the dangers of asbestos, there were no signs put on the mines that warned you that asbestos was dangerous.'

He recalls a time when he was a building foreman working at the Riries asbestos village. He walked into a house and noticed that the pillows were white where the residents' heads lay, but the rest of the pillow was blue. The wind carried the asbestos from the mills, which then seeped into homes through roofs and windows. In the past, dust control was poorly managed and great clouds of blue asbestos could be seen billowing from the mills. In 2002 Daniel was diagnosed with pleural asbestosis and now has only one functioning lung. Koot has also been

diagnosed with asbestosis. Daniel is concerned for his brother's health. He informs me as we leave his farm that he thinks the asbestos is now in his brother's stomach.

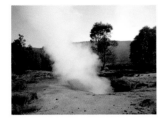

Burning underground coal fires, Emalahleni (Witbank), Mpumalanga, 2011.
The decommissioned Transvaal and Delagoa Bay Coal Mine is known to be one of the most dangerous abandoned mines in South Africa. Mining at the state-owned colliery started around 1896. Following closure in 1953, the area became unsafe because of the underground burning of the remaining support pillars. Even before mining had stopped, underground fires occurred and the surface began to collapse. Sinkholes and cracks appeared where the pillars had given way, allowing oxygen into the underground workings and fanning the fires. The underground coal fire is an environmental catastrophe, characterised by the emission of noxious gases. Such fires are responsible for atmospheric pollution, acid rain, land subsidence, and increased coronary and respiratory diseases. They destroy floral and faunal habitats and cause human suffering.

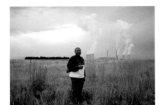

Johannes Ndila, Lethabo Power Station, Free State, 2011.
Johannes Ndila has worked as an ash cleaner at the Eskom Lethabo Power Station in the Vaal Triangle since 2007. Historically, the Vaal coalfields were the first in the country to be exploited, hosting a number of coal-fired power stations as well as steel and heavy industry. The Vaal Triangle was declared a priority area in April 2006 by the Minister of Environmental Affairs owing to the concern about pollutants in the air. The area is home to large informal settlements that use coal as a fuel source, which impacts directly on the health of local residents.

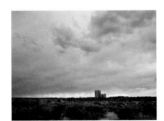

Decommissioned Pomfret Asbestos Mill, Pomfret, Northern Cape, 2012.
The Pomfret Asbestos Mill, which ceased operation in 1986, stands as a relic in a remote region of the Northern Cape on the edge of the Kalahari. Its remnants protrude from the scarred land as a reminder of an industry that has left behind masses of sick men, women and children. Even though the landscape surrounding the mill has been rehabilitated, the legacy of the mine will continue to endanger the lives of many and pollute the land for generations. Today, former Angolan members of the 32 'Buffalo' Battalion, a counter-insurgency unit of the South African Defence Force, inhabit Pomfret. The men and their families now live in the shell of a former army base, struggling to survive in an area with massive unemployment.

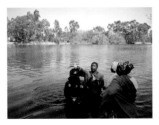

Ritual offering, Vaal River, Maccauvlei area, Free State, 2011.
Jeremiah Stoaba and his wife Maria from the Apostolic Church of Zion perform an animal sacrifice on the banks of the Vaal River in the Maccauvlei area, on the periphery of the New Vaal Colliery. Two to three times a year they speak to the ancestral 'river gods' here. The banks of the Vaal River are rich in minerals, including coal, copper, gold, uranium and other associated minerals, yet is relatively unscarred by mining. There has been a lot of controversy around the award by the Department of Mineral Resources of prospecting rights to mining companies along the Vaal River. If the development of mining continues, it would have a major impact on the ecology of South Africa's most important river.

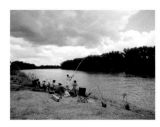

86

Fishing on the Vaal River, Vereeniging, Gauteng, 2011.
An estimated 12 million people in four provinces, Gauteng, the Free State, North West and Northern Cape, rely on water from the Vaal River system. Reports reveal that by 2014 the water will not be suitable for human consumption, posing a threat to health, the economy and food production. Researchers have established that the problem is caused by acidic water seeping from both waste from abandoned mines and the discharge of untreated acidic mine water into rivers and streams tributary to the Vaal River system. If the government does not intervene urgently, the cost involved could well add up to billions of rands, and the looming pollution crisis could hamper growth and cause a plague of health problems. Mariette Liefferink, chief executive officer of the Federation for a Sustainable Environment, warns, 'Toxic water affects the soil and neural development of the foetus, which leads to mental retardation, and can cause cancer and cognitive problems.'

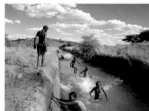

87

Collecting water, Gong Gong, Northern Cape, 2013.
A woman and child draw water from the Vaal River, in an area that was once rich with alluvial diamonds. 'Gong Gong' was the name given to one of the early mining camps along the river.

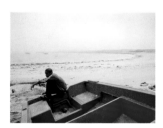

88–9

Swimming in the 'Long Sea', Diamanthoogte, Koffiefontein, Free State, 2013.
The suburb of Diamanthoogte ('Diamond Heights') is home to a predominantly coloured community that lives on the outskirts of the diamond-mining town of Koffiefontein in the Free State province. During the summer months children enjoy swimming in the canals, which they refer to as the 'Long Sea'. The canals carry the overflow of water through the town from Kalkfontein Dam and the mine dam to outlying farms. Koffiefontein became a stopover point for transport riders travelling between the diamond fields in the south and the gold mines to the north during the 1800s. After diamonds were discovered here, Koffiefontein developed into a mining town. The town has a significant military history; it was seized by the British during the South African (Anglo-Boer) War and was later used as a detention camp in the Second World War. Among the internees was John Vorster, who later became prime minister and president of South Africa. The mine has been closed several times over the years but continues to recover some of the most valuable diamonds in the world.

91

Malcolm Cloete, Hondeklip Bay, Northern Cape, 2012.
Malcolm Cloete, 23, has lived in Hondeklip Bay his whole life. Squeezed between the diamond-mining conglomerates Trans Hex and De Beers, the 1500 residents of Hondeklip Bay remain a marginalised community. Malcolm comes from a long line of fishermen; his father and his father's father all relied on the ocean as a means of income, yet this lifeline has been cut. With no work and no future prospects, Malcolm and his friends sell crayfish to provide for their families. Malcolm spent a year working as an informal diamond digger. The nights were cold and long, and he faced the risk of being caught. Even though he earns less money selling crayfish than digging for diamonds, he has chosen to stop digging. He says, 'Many of the guys have cases now for illegal mining, they must go to court, we are still young, we cannot have that on our name, they do not dig because they want to, they dig for a living. Why would I endanger my life for that?'

92–3

The old Muldersdrift Road, Melville Koppies, Johannesburg, Gauteng, 2013.
The Muldersdrift Road was in use up to the 1960s but is now no longer open. It winds around the side of Melville Koppies, the site of an early Iron Age settlement.

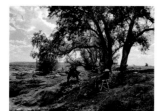

94

Paulus and Putsoane, security guards, disused St Helena 4 mine, Welkom, Free State, 2012.
Security guards Paulus Makatane and Putsoane James Staal watch over the breaking down of the St Helena 4 mine and metallurgical plant. They have always been associated with the mining industry. Paulus lost a brother to silicosis; he worked at Free State Geduld Mine No. 5 (nicknamed Freddie's), as did Putsoane. When the latter started work as a miner in 1978, his job was to control the dust levels underground by spraying the walls with water after explosives were detonated in the tunnels. He was never provided with respiratory equipment and spent 17 years of his life underground, inhaling dust. In 2005 he was diagnosed with silicosis. He was given seven days of rest and on his return to work he was dismissed. He received R3000 in compensation.

 The first mining lease in the Welkom area was awarded to the St Helena Gold Mining Company in 1941. Today the site is owned by Harmony Gold. The gravel still holds considerable gold value and is transported to central Harmony for processing.

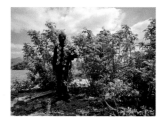

95

Jonas Mooka, Ga-Pila village, Limpopo, 2012.
Jonas Mooka stands among the ruins of the once thriving village of Ga-Pila, whose 13,000 residents were forced to move off their ancestral land and resettle in Sterkwater, to make way for the expansion of Anglo Platinum's Potgietersrus Mine. He remembers a time when there was room for his cattle to graze, but since the platinum mines have come, the land surrounding his community has become a mine dump. Malose Mabela, a fellow cattle herder who was born and brought up in nearby Ga-Molekane, has a similar story. 'I have learned that the only communication the mine has with the community is when they want to move us to new residences. That is the only time when a clear communication begins. We tend to be poorer and poorer.'

 Malesela Phillipos Dolo, a community leader from Ga-Molekane, says, 'Thirty-five families living in the Ga-Pila village refused to move. In 1996 Anglo Platinum started negotiating with the community to relocate them to Sterkwater. Some of the families refused to go. For the past 12 years we regarded the village of Ga-Pila as a ghost town, as the 35 families are scattered and have lived without basic services, electricity, water, schools and clinics. These services were available before the relocation but they were destroyed to punish those who refused to go to Sterkwater. Only last year in December 2011 the government and Anglo Platinum were forced to resupply electricity. The municipality is also tanking water house to house. Karin Bosman, an environmental chemist, warned the community not to use the water for human consumption. Water samples were taken from the river nearby, where she found high concentrations of nitrates, sulphates and dissolved salts.'

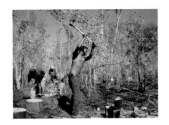

Moses Masuku, Springs, East Rand, Gauteng, 2011.
Australian blue gum trees were imported to South Africa in the late 19th century. They were used as support beams in the tunnels of the mines. Aurora Empowerment Systems has given the men permission to cut the wood on the periphery of Grootvlei Mine, which will be sold as firewood.

96–7

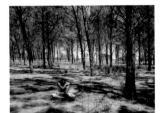

Mpho, commercial sex worker, Rheeder Park, Welkom, Free State, 2012.
Hidden away in the bush and trees that grow near the mine dumps in the gold mining town of Welkom, Mpho lies in wait for her next client. She is 25 and works as a prostitute. Originally from Lesotho, she arrived in Welkom in 2011 and lives in Rheeder Park. She says, 'I came to South Africa to find work. My clients are white men from town, mineworkers and Zama-Zama informal diggers.' Mpho is fortunate to have had no bad experiences but her work colleagues paint a bleak picture. Many have been raped at gunpoint, robbed of their money and cellphones, and beaten. One of Mpho's colleagues says, 'We are not safe. We try our whole level best to do everything we can to survive in life, because we are struggling.'

99

Willem Badenhorst, asbestosis victim, Wrenchville, Kuruman, Northern Cape, 2012.
Willem Hendrik Badenhorst was born in 1942 and grew up in a remote region of the Northern Cape. He has provided his labour to the asbestos mines in Heuningvlei and Pomfret. Willem started his career in 1961 as a plumber at the Pomfret Asbestos Mine, owned by Cape Plc and later Gencor Ltd. In 1996 Willem was diagnosed with first-grade asbestosis and received R31,440 in compensation for this occupational disease. A number of years later, asbestosis victims in the Northern Cape and Limpopo Province, including Willem, won a legal battle against asbestos mining companies and were awarded compensation. In 2003 Willem was told that the compensation amounted to R1753.22 for his time working under Cape Plc and R1266.59 for his time under Gencor, a total of R3019.81. This was in addition to his previous compensation for an occupational disease. Willem refused to accept the amount offered, as he had heard that people were receiving R400,000 and more. Since then the Asbestos Relief Trust and the Kgalagadi Relief Trust have been set up to compensate asbestos-related cases. Willem approached the Asbestos Relief Trust as they dealt with Gencor, for whom he had worked, but because he had already made a claim and accepted money, he found he was not entitled to receive further funds.

100

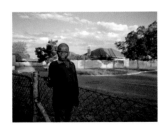

Zoyisile Mgqatsa, silicosis victim, Odendaalsrus, Welkom, Free State, 2012.
Zoyisile Mgqatsa, 50, started his mining career as a rock drill operator at Merriespruit Mine in January 1983. He then worked for Freegold 2 and 4, which later became Tshepong Gold Mine. In 2006 he developed a severe cough and after a check-up at the Ernest Oppenheimer Hospital he was diagnosed with tuberculosis. He continued to work as a chair lift operator. In April 2012 he was diagnosed with incurable silicosis. He was then dismissed, being accused of helping informal diggers by smuggling gold-bearing rubble out of the mine. He believes his dismissal is a way for his employer to avoid offering him compensation for his illness. Though he has sought help from the Commission for Conciliation, Mediation and Arbitration (CCMA), to date he has not received any compensation. He now survives on an allowance from the Unemployment Insurance Fund (UIF). He supports his family in the Eastern Cape, including a son at university, but his deteriorating health and financial burdens are becoming a major concern for him.

101

In December 2012, Richard Spoor, a South African activist and human rights attorney, filed a class action against 30 gold mining companies on behalf of tens of thousands of mineworkers who have contracted silicosis. One of them is Zoyisile's employer, Tshepong Gold Mine (formerly Freegold 2 and 4). It is estimated that one in four gold miners in South Africa suffers from silicosis.

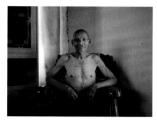

102

Molatlhegi Mongotleng, peritoneal mesothelioma victim, Garuele village, Northern Cape, 2012.
Molatlhegi Singleboy Mongotleng lives in Garuele village in the Northern Cape Province, near Kuruman. He started his mining career as an underground winch-driver for the Griqualand Exploration and Finance Company (Gefco) in 1960 and remained there until 1970. While at the mine he met his wife, who worked in the catering department. On the day I met Molatlhegi, he had returned from Kimberley where he had undergone an operation to remove cancerous tumours in his stomach, caused by the ingestion of asbestos. His wife, who died a number of years ago, was also diagnosed with asbestosis.

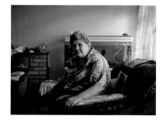

103

Marie Joubert, Komati, Mpumalanga, 2011.
Mrs Marie Joubert, 63, has resided in the small town of Komati since November 2010. She lives alone after losing her husband to emphysema and her two sons to lung cancer. For 20 years they owned a number of shops serving mining villages, but with the closure of some mines, the mechanisation of others, and the demolition of mining villages, they lost their clientele. Their remaining shop served hauliers and their huge trucks at the Xstrata Tweefontein coal depot. On 16 September 2011 a documentary film was aired in the Netherlands on mining in South Africa. The Jouberts were filmed talking about their health and the negative effect the coal dust had had on their livelihood. As a result of this documentary the mining company approached the Joubert family and offered to purchase their store. The Jouberts were unable to pay a lawyer for legal advice and decided to ask for R700,000. Mrs Joubert says, 'This is not enough, we were scared and not sure what to do. Everyone is gone now. Nothing will bring my family back.' Mrs Joubert passed away on 18 January 2013.

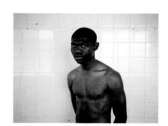

104–5

Thokozani Sikhakhae, security guard, East Rand Proprietary Mine (ERPM) Cason Shaft, Johannesburg, Gauteng, 2011.
East Rand Proprietary Mine (ERPM) was originally established in 1896 and was one of the deepest mines in the world, at 3585 m. It is situated near the town of Boksburg, 25 km to the east of Johannesburg. Underground mining was suspended in October 2008 as a consequence of the death of two employees, who were overcome by carbon dioxide asphyxiation. The mine has since remained closed.

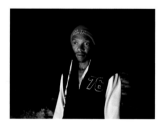

106–7

Sikhumbuzo Douglas Matsha, informal diamond digger, Hondeklip Bay, Northern Cape, 2013.
Sikhumbuzo Douglas Matsha, 32, lives in the coastal village of Hondeklip Bay. Douglas is one of the informal diamond diggers who survived a horrific tunnel collapse in the disused Bontekoe Diamond Mine, situated in the Komaggas area in Namaqualand, on 22 May 2012. Douglas is still recovering physically and mentally from the disaster.

Douglas and his friend Aubrey arrived the day before the tragedy. They had to wait their turn to enter the tunnels. Douglas recalls seeing very young boys, some as young as 16, with their fathers cajoling them to go down. A ladder made of wire took them down 6 m into the waiting room, from where two tunnels led them through to the face. Here Douglas noticed a young boy and his father using a jack hammer to break the soil. At that moment a huge rock suddenly cracked, and soil began falling all around them. They needed to get out fast. 'The tunnels are very small; you cannot stand up, slowly crawling between the waiting room and the face. It is also extremely hot, there was no fresh oxygen to breathe, and the dust was overwhelming.'

As they were about to exit, Aubrey suddenly realised he needed to go back to the face to get the last gravel bag of diamonds. At that moment the tunnel just folded. 'It was quick, you couldn't move, I knew then my life was over, I had to accept I was dead already.' When Douglas opened his eyes, the dust had settled. He was wedged in under a large rock and could not move. After removing the debris from around him and slowly dislodging one leg at a time, he then saw his friend Aubrey and realised he was dead. Five diggers escaped the collapse. 'God's grace I survived.' As a man helped him to the surface, he asked whether anyone was still alive. 'I said there

is no hope; everyone at the face is dead. It made me very sad, as I remembered the young boy and father, they never came out.'

Since the tragedy Douglas has taken up contract work. He does not want to go back to digging but he worries about his future. He believes the solution would be to set up diamond-mining cooperatives, which would work in partnership with the government.

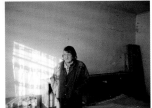

108

Chappy, De Bruin Park, Ermelo, Mpumalanga, 2011.
Mr Chiapperini, also known as 'Chappy', lives in De Bruin Park, Ermelo. In 1998 Imbabala Mine began blasting for coal. This has resulted in major damage to his home: large cracks can clearly be seen throughout the property. Chappy approached the mine and suggested they use two smaller charges for blasting rather than one large one, as this caused huge ground vibrations. Their response was that they were following rules laid down by Sasol. When Chappy asked if they had done any ground tests in the vicinity, they could not reply. Chappy is continuing his battle with the mine, as he wants them to be held responsible for all the damage to his home.

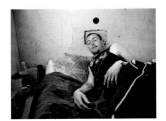

109

Willie, Cinderella Hostel, Boksburg, East Rand, Gauteng, 2011.
Michael Wilhelm Calitz, nicknamed 'Willie', 26, rents a room in Cinderella Hostel. He works as a street beggar to earn money and support his son Dillan, who lives with his mother. If he does not provide the necessary mainte-nance for his son, he could go to jail. Michael says, 'When I was 19 years old, my father passed away. Everything started going wrong in my life. I started taking drugs and became very depressed. I have tried to commit suicide three times.' Cinderella Hostel was once the migrant worker compound for Cinderella Deep Gold Mining Company and later the East Rand Proprietary Mine (ERPM). It is one of many hostels that were built to house men from rural communities who left behind their wives and children to work on the mines.

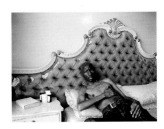

110

Mahlomola William Melato, silicosis victim, Oppenheimer Park, Tabong, Welkom, Free State, 2012.
Mahlomola William Melato rests during the heat of the day at his home in Oppenheimer Park. Since being diag-nosed with silicosis, Mahlomola's weight dropped from 80 kg to 49 kg. He suffered from shortness of breath, a debilitating cough, general body weakness and discoloration of the skin.

In 1986 Mahlomola began an apprenticeship at the Harmony Gold Mine in Welkom as a boilermaker. After completing his apprenticeship in 1990, he became a teacher but returned to the mining industry in 2007. In 2008 he was diagnosed with tuberculosis and in 2010 with silicosis, previously known as miner's phthisis, and was laid off from his job. He said, 'Young men who started on the mine as an apprentice did not know the risk of TB and silicosis. If I knew the risks involved I would not have worked in the mines.'

Though he signed a Medical Incapacity Agreement with Harmony Gold Mining Company, which stipulated that if he became medically incapacitated he must be given an alternative position as well as medical assistance, neither had been provided in Mahlomola's case. The only financial support Mahlomola received was R3000 per month from the mining industry retirement fund. This fund needed to cover his medical costs, living expenses, university fees for his children and the bond on his home. He also applied to receive government compensation, but he was notified by the Medical Bureau for Occupational Diseases that he did not qualify for compensation.

Sadly, Mahlomola died on 21 May 2013, and was buried on 1 June.

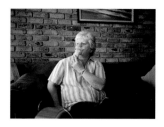

111

Anna Grobler, Emalahleni (Witbank), Mpumalanga, 2011.
Anna and her husband, Martiens Grobler, moved onto their farm in Witbank in 1988 and have lived there for 24 years. They share the farm with their son and daughter, who both have families of their own. Seven years ago Westcoal Mine began extracting coal on the border of their property. Soon after mining commenced, the Grobler family's health began to deteriorate. Anna's breathing has been badly affected and she relies on respiratory apparatus to relieve the tension in her lungs due to coal dust inhalation. The family members suffer from sinus problems and take antihistamine pills to relieve the symptoms. Anna's grandson often wakes up with a bleeding nose and sleeps with a steam machine in his room to clean the air. Black dust is a constant problem, as it settles on the walls and furniture, and windows and doors need to be kept closed. The value of the property has also been drastically reduced.

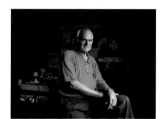

112

Thomas Richard McLean, Holly Country, Free State, 2013.
The biggest mining catastrophe in South Africa's history took place on 21 January 1960, when 435 miners lost their lives at Coalbrook North Colliery. Thomas Richard McLean, 73, the last resident living in Holly Country, was there on the day of the Coalbrook mine collapse. He had signed on as an underground electrician on 16 January, five days before the tragedy. 'I was just in time, the electrician on the surface got sick and so I had to take his place repairing cables. I was told the pillars collapsed, they were not thick enough. There was a different story in the courts at that time, they did not mention the collapse of pillars. They spent a long time trying to save those people, but nothing.'

The colliery has changed ownership several times and in 1989 was officially shut down by Goldfields. During these changes Thomas continued working for the mine. Even though very little remains, the mining village of Holly Country is still intact and now provides affordable accommodation to people in the area. Thomas continues to work as an electrician for the new owners. He recalls a time when it was a beautiful place. 'There were a lot of tears when the colliery closed.'

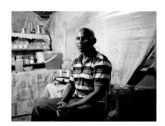

113

Zenzile Nxenge, Wonderkop, Marikana, North West, 2013.
Zenzile Nxenge, 39, works at Lonmin Platinum Mine as a rock drill operator. On 12 October 2012 Zenzile was arrested and his ID book was confiscated. At Phokeng police station Zenzile was tortured for over two days. 'They covered my head with a plastic bag and began to beat me, then started to shock me on my head and thighs.' He was suspected and falsely accused of murdering Daluvuyo Bongo, the National Union of Mineworkers (NUM) branch secretary for Lonmin Western Platinum. Bongo lived in Wonderkop hostel, where he was found lying in a pool of blood. He had been shot six times. Bongo had participated in an inspection of Marikana set up by the Farlam commission of inquiry.

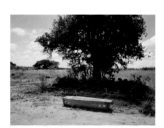

114–5

Unmarked coffin, Sekuruwe village, Limpopo, 2012.
On 27 November 2012, the remains of 149 people were reburied at Sekuruwe village. Their bodies had been exhumed by Anglo Platinum's RPM Mogalakwena Section Mine, to make way for the expansion of a tailings dam.

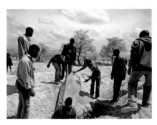

116

Reburial service, Sekuruwe village, Limpopo, 2012.
The exhumation by Anglo Platinum's RPM Mogalakwena Section Mine of 149 graves from a section of the Blink-water farm was not without controversy. A mechanical digger was used in the process. Some bones were broken as a result and the skeletons were not all kept separate. Community members became suspicious when they were restricted from witnessing the exhumation of family members. The situation was further exacerbated when on the day of reburial they noticed that the number of coffins did not correspond to the number of exhumed graves. Protests ensued, and 47 people were arrested. After failed attempts to stop the reburial, the bodies were swiftly buried. The archaeologist Frans Roodt from the Limpopo Heritage Resources Agency was approached to help and after an investigation lasting several years by Amanda Esterhuysen and forensic anthropologist Professor Maryna Steyn of the University of Pretoria, their findings were shared with the community of Sekuruwe. On 27 November 2012 the remains of 149 people were reinterred. After a long and emotional battle, the Sekuruwe community had finally reburied their own people and appeased their ancestors.

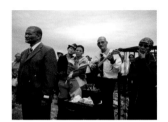

117

Funeral for Niklaas Badenhorst, Effel, Northern Cape, 2012.
His tombstone reads, 'In loving memory of Niklaas, born 19/07/1938, died 13/11/12, buried 24/11/2012, remembered by your family, rest in peace.'

On Saturday, 24 November 2012, Willem Hendrik Badenhorst buried his brother in their home village of Effel in the Northern Cape. Niklaas Badenhorst was 74 and died of asbestosis. During his mining career he worked as an 'engineering helper' for the Griqualand Exploration and Finance Company, a 'jumper driller' for Pomfret Asbestos Mine, and an assistant for drilling contractor Loot and Jeppe at Jebola Mine. He also worked for a transport contractor, carrying asbestos fibre from Bute to Riries.

Willem Badenhorst believes his brother did not get the compensation he deserved as a result of his illness. 'He was due to receive R78,000 from the Asbestos Relief Trust, but there were several deductions made and in the end he only got R13,000. So where is the other money?' Another angry resident of Effel remarked, 'I have lost four of my brothers and my father to asbestosis and the compensation they gave for my father was very poor. Two of my brothers refused the compensation completely.'

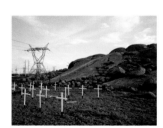

118–9

Memorial crosses, Wonderkop, Marikana, North West, 2012.
Thirty-four white wooden crosses symbolise the slaying of the Lonmin miners at the Koppies in Marikana by the South African police on 16 August 2012.

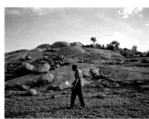

121

Mzelelo, Wonderkop, Marikana, North West, 2012.
Mzelelo, 32, comes from the Eastern Cape. He practises as a sangoma and works as a rock drill operator at Lonmin Platinum Mine. He earns a basic wage of R6538 and a sleep-out allowance of R1950 per month. He also receives a monthly bonus of R550, to which only rock drill operators are entitled. According to Mzelelo, his ancestors gave him the cow-tail whisk and stick while he was sleeping. It enables him to have visions; it guides, instructs, leads and protects him and shows him the way. It has given him the power to communicate with those who are not on the earth with us. He did not come to the koppie of his own free will, but was told to come by the ancestors and give the dead miners a report. By sprinkling snuff, which represents the beginning of communication between him and the dead, he is able to listen more carefully to the dead miners' concerns.

He explains, 'Unfortunately what these miners died for never happened, so I am here to tell those that are

dead. They died for nothing; everything that they demanded from the mine was never met. My heart is too sore; I know that these men died for the community and their children. I am here to share with them the on-going events at the commission of inquiry and what will happen in the future. They are seemingly very angry, so I want to know what is the step forward from here?'

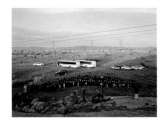

122–3

Memorial gathering, Wonderkop, Marikana, North West, 2012.
On Tuesday, 7 November 2012, a gathering of Democratic Alliance supporters held a memorial service for the 34 striking Lonmin workers who were killed by the South African police on 16 August 2012 at the Koppies in Marikana, near Rustenburg.

Alex Salang, a 32-year-old community activist who lives in Mmaditlhokwa Township, Marikana, voices his concerns. 'In the beginning we had farmers helping the community like my mother, we drank the borehole water, it was clean and not polluted. Even though we had limited choices and earned very little, we had electricity and a sustainable life; in return we worked hard, we had no options and had to get used to that life. But now we cannot live without mining activity, because it is one of the industries that are keeping our economy alive, they are making sure that some of us are getting employed so we can live. Those guys are making billions, so one billion can cover whatever we need in this village. Why aren't they doing this? We cannot just be happy that our economy is growing while we do not benefit. We cannot just go to work and earn R4000. How can we develop ourselves with this? If the mine closes, I am not sure what we are going to do as a community. We cannot then create farming activities, this land is covered in damaged soil, and no vegetation can grow here. Farming should be the future in South Africa, it is rotating, it is sustainable.'

Alex expresses the importance of acknowledging and addressing the core problems behind the Marikana massacre rather than focusing on the events that unfolded on that day. He believes the workers were pushed to desperation in getting their voices heard. They were fighting for their right to earn a better wage to support their families and improve their way of life. There is massive unemployment and lack of development, poverty is rife, underage pregnancy and substance abuse are common. 'Can you hear the noise? That is the mine. We cannot sleep at night; we have commitments in the morning. Just hear, just hear, it is the ventilation and plant operation activity, the milling. We live like hell.'

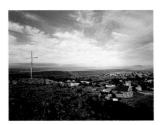

125

Merweville, Western Cape, 2013.
The small town of Merweville lies at the end of a scenic Karoo road. With no thoroughfare onward to another destination, its existence is almost untouched by major development and tourism. The peaceful community is reliant on sheep farming, nestled in a quiet valley surrounded by gently rolling mountains and scenic vistas. But a threat to the community's existence looms on the horizon. Merweville is situated in an area that may become part of a large-scale plan to explore for shale gas. This has become the main topic of discussion among community members, especially farmers. Exploration could damage the aquifers that provide drinking water to the community and sustain plant life in the delicate ecosystem. The community understands the importance of development within the town but sees it as a short-term benefit compared with the long-term damage once the shale gas companies have moved on.

Three generations of the Bothma family have lived on the land. Samuel Abraham Bothma has witnessed the environmental damage caused by exploration on his uncle's father's farm, Skietfontein, in the Aberdeen district. 'In 1938, the American company Soekor came in search of oil and bored around 30 holes in the Western and Northern Cape, one of them on the land neighbouring my farm. It was then closed with a tap and lay dormant till 2012. Three months ago Professor Gerrit van Tonder from the University of the Free State came and opened the tap: powerful high-pressured gas was released. You can see that nothing grows around the hole. This drilling is not good for us, it will affect the whole area, and we will not be able to farm again.'

Jonathan Deal, anti-fracking campaigner, environmental activist and chairperson of the Treasure the Karoo

Action Group (TKAG), says, 'When growth falters, politicians panic and they make bad choices, and fracking is another one of their bad choices.' On 8 September 2012 Susan Shabangu, Minister of Mineral Resources, lifted the moratorium on shale gas exploration on the instruction of the Cabinet. Jonathan believes that 'subsequent to lifting the moratorium and revealing their task team report they have realised that the report is actually a very inadequate document on which to base an irreversible decision on a mining technology like fracking'. Among several aspects that Jonathan criticised in the report was its failure to mention that after 12 years of fracking in the United States, the negative health effects are only starting to manifest themselves. 'These illnesses have been around for a while, but because of the specialised nature of the chemicals that are used in fracking, your average doctor or even a physician would not pick up the presence of those chemicals, unless a specific test is performed to identify the chemical when examining the patient. And if he is not aware that the patient has been exposed to that type of chemical he is not going to do those tests. There is not one word in the report from a South African medical professional about the health and safety aspects of fracking and the exposure to fracking-related pollution in local communities.'

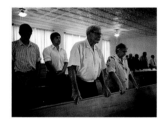

126

Sunday prayers, Dutch Reformed Church, Merweville, Western Cape, 2013.
In the town of Merweville, the farming community gathers for Sunday prayers at the Dutch Reformed Church. A prayer is always said for the protection of the land and water from shale gas exploration. The local minister, Herman Burger, says, 'You will see every house in the town has its own dam with fresh drinking water from underground. It is a dry and arid part of the country, but the water gives life and that is our concern: this source of life is going to be threatened.'

 Gina Mans of the Women's Agricultural Association, and a member of the congregation, says, 'Money is going to overrun everything, we do not have a chance here. The government is standing to gain financially. We are having prayer meetings and holding events to try and stop the fracking. Our son is presently studying at the Agricultural College, but there is not a chance that he is going to be able to farm again. Underground water is making it possible for us to sustain farming; one may bore ten kilometres away but it is still going to contaminate our water. We are now testing our water so we will be aware of when there is contamination. We are going to get illnesses and it is not going to benefit our town. I have lived here for 26 years, our whole way of life is going to change. We feel the government does not care about us because we are so scarcely populated.'

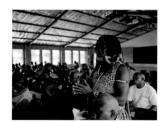

127

Community meeting, Motlhabe village, Pilanesberg, North West, 2012.
Philiciano Chelaole is a traditional doctor and concerned resident of Motlhabe, one of 32 villages that fall under the platinum-rich Bakgatla-Ba-Kgafela tribal community. Philiciano voiced his concerns about Pilanesberg Platinum Mine to Mariette Liefferink of the Federation for a Sustainable Environment. 'We are very concerned for our village Motlhabe. We have claimed that the mine should belong to us but we are benefiting nothing. Our ancestors' graves have been exhumed without us being told. We are now appealing to you, as our children are getting nothing. We have been crying for a very long time.'

 Throughout the meeting, Mariette covered several key points, from the *Social and Labour Plan for the Mining and Production Industries*, yet when Mariette asked the community if they had had any engagement with the mine, members responded, 'No.' 'Has no one come to ask you your problems?' 'No.' 'Are you happy with the mine?' 'No.'

 Another community member said: 'When our youth should be employed in the mines, the mine would request from us a number of requirements, which they have realised our youth do not have. This is the tactic they use in order to block us from getting access to employment. When they respond to our pressure, they would employ them, but once they are employed they would be given extremely difficult duties and are only paid R1500 per month. We know that people from outside the village get better salaries than the local youth and their application requirement consists of solely their ID book.'

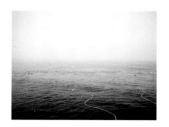

128

Alluvial diamond divers, Hondeklip Bay, Northern Cape, 2013.
Jirts Vuurbom and Jonny Dawn vacuum the ocean floor in search of alluvial diamonds. Langklip Diamante, established in 1996, operates out of Hondeklip Bay. They have permission to search for alluvial diamonds in the waters of Hondeklip Bay.

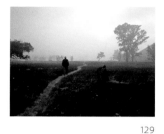

129

Decommissioned Delagoa Colliery,Emalahleni (Witbank), Mpumalanga, 2011.
Early one morning on Delagoa Colliery, a man goes in search of coal. The local community of KwaGuqa lives near the abandoned mine. David Ndlovu is one of many who have fallen victim to sinkholes from abandoned mines in the area. In 1999, he was walking to work along one of the many footpaths that crisscross the mine when a sinkhole gave way beneath him. As he sank into the ground, he was severely burnt up to his waist by the coal, which has been smouldering underground since the mine was decommissioned in the 1950s.

Afterword

I had spent 11 years working between my home town of Johannesburg and London, where I was based. In 2011 I decided to return to South Africa. Landing on home soil felt very different this time: I was here to stay. I would be returning to focus on several projects that were up to now confined to notebooks and mental thoughts; one of them would inevitably evolve over two and a half years into the *Legacy of the Mine*.

For more than a century, South Africa has been associated with mineral wealth, both in diversity and abundance. The demand for gold, diamonds, coal and platinum has gone from strength to strength, often shifting in accordance with the political economy and the availability of foreign markets. It has helped shape the landscape as we know it today. Mineral exploitation by means of cheap and disposable labour has brought about national economic growth, making the mining industry the largest industrial sector in South Africa.

Although South Africa is no longer the leading global exporter of gold, and now falls behind China, Australia, the United States and Russia, it is still recognised globally for its abundance and variety of mineral resources, which account for a significant proportion of world production and reserves. South Africa remains one of the leading producers of gold, diamonds, base metals and coal. The mining industry employs an estimated half a million people. In 2009 the Chamber of Mines estimated that around R200 billion (£15 billion) in value was added to the local economy through the intermediate and final product industries that use minerals produced by South Africa's mines.

This book unfolded after my attention was drawn a number of years earlier to the environmental implications and historical and current social aspects of the gold mining industry around Johannesburg. Yet on my arrival the project quickly enveloped me in research, which in turn began to take me further afield, with early visits to mining provinces including Gauteng, Mpumalanga and the Free State. It became clear as the project progressed that my subjects did not always directly reflect the legacy of mining-based pollution; rather, the concept of 'the mine' became a thread that helped me frame my work. I was originally drawn to the way in which mining had revealed the impact of its legacy on the environment, but my experiences soon revealed something deeper.

The inspiration for choosing my subjects and the space in which I worked was not defined by statistical or scientific evidence. Rather, it was the product of personal experience, ongoing investigation and knowledge gained through long hours of travel along potholed roads, following the trail of wind-blown mine dust, overwhelming vast landscapes, dotted with townships and mining communities across South Africa.

The potential for expanding this project soon revealed itself – beyond the peripheries of the city, into the small towns and rural communities surrounding areas of both abandoned and ongoing mineral activity. As I continued to explore the topic further, it was evident that 'the mine', irrespective of the particular minerals extracted, is central in understanding societal change across the country. Entering these spaces with little pre-existing knowledge allowed me to explore these enormous socio-economic cleavages and continuities through engaging with those who were most affected – who were, generally, the most marginalised. This enabled me to channel my conception of 'the mine' into visual representations that gave agency to these forgotten communities. 'The mine' provides a framework for portraying the seemingly unrelated stories of my human subjects in relation to their environment. The countless stories of personal suffering are brought to the surface and the legacy of 'the mine' is revealed.

The 'legacy' of mining is apparent in many ways – through land rendered unfit for alternative land uses such as ecotourism and agriculture, through public health crises within local communities unequipped to cope with the burden of air, land and water pollution, and through the disruptive influence of historical labour exploitation impacting on family structures and cultural positioning. Thus, unveiling these stories, through investigative

fieldwork across the country, allowed me to delve deeper into the effects of 'the mine' on the profoundly polluted landscapes that are constantly negotiated by the local communities.

I set out to build a visual narrative that provides agency to those whose lives and livelihoods have been destroyed by mining processes and the long-term environmental ramifications, to expose the far-reaching neglect by the successive governments and corporate bodies that have driven the mining industry, to explore how people have coped within their circumstances, and to sensitise a public saturated with the idea of 'climate change' by focusing on the local problems that we can actually see. The objective was thus to travel the length and breadth of the land to reveal through the lens the forgotten communities that the mining industry has left behind.

There is a new form of activism taking shape in South Africa, not one of a political nature but one with an environmental concern. With the ongoing support of these environmental activists and community leaders, I have been able to reveal the human cost of mining on various communities, their environment and health.

This project not only captures isolated moments of the lives of ordinary people affected by the legacy of mining but also challenges the ideological portrayal of 'the mine' as a symbol of progress, prosperity and wealth. My subjects thus become symbols of the struggle for environmental and social justice in the country. By congregating a disparate network of people and places, I hope to provide a space for them to be heard and for the magnitude of the damage to be felt.

It became more evident as the project evolved that it resonates universally and can be used to showcase issues that we are all familiar with, irrespective of where we live: issues of greed, inequality and environmental degradation.

I journeyed into several provinces where mining is a prominent feature. For instance, the Free State contributes 14.1 per cent to the country's total mining production, the fourth highest among all the provinces in South Africa. Mining activities planned for the future could make Limpopo the richest province in South Africa. Another province I explored is the Northern Cape, which is rich in minerals. The country's chief diamond pipes are found in the Kimberley district, which is often referred to as the Diamond Capital of the World, but there are other minerals, including iron ore and copper as well as asbestos, an industry that is now defunct, though its effects are still felt by the community of Kuruman and surrounds. In the Western Cape there is concern for the future of the Karoo as oil and gas companies look to the area in an attempt to undertake shale gas mining (more commonly known as fracking). Communities in the areas that could be affected shared their suspicions with me about the benefits and processes involved. A poignant point made by a resident of Merweville was that if the environmental and health management of mining processes by authorities across other parts of South Africa is anything to go by, we are in for big trouble.

In the North West mining is responsible for more than a third of the province's gross domestic product. In particular, platinum comes from the Rustenburg district, which produces more platinum than any other area in the world. A particular point of interest associated with the platinum belt is that as the mining companies follow the mineral in huge opencast mines, all the communities who live in the path of the mine are forcibly displaced, some into a completely unsustainable situation without enough land to live on or any potential for employment.

The platinum industry in the North West has been fraught with controversy of late, as the labour unrest at Marikana attests. Not only does Marikana focus attention on the need to restructure the cheap labour migrant system but it has also highlighted the ongoing health risks miners face during employment and the meagre compensational benefits awarded to them once employment has ended. Wildcat strikes, invariably the desperate measures of miners simply wanting to improve their wages and living conditions, are nothing new in South Africa, yet few would have anticipated the level of violence that would unfold at Marikana on 16 August 2012.

I did not endeavour to photograph men and women at work in the mines and, even though I went underground to witness the physical hardships these miners are confronted with day in and day out, the process of mining was not of interest. Rather, their after-work, post-conflict environs were more revealing to me. Looking into their lives at home gave so much more meaning to why mining communities rise up and fight for very little improvement to their lives. I felt compelled to visit the area of the massacre, not out of a need to document the unrest as it unfolded, but its significance for the community several months on. Their ability to cope with these traumatic events will inevitably affect them for the rest of their lives.

Visiting Witbank, 'the Coal City', now renamed Emalahleni, the 'place of coal', revealed the extent to which mining has impacted on the land and people. Large parts are uninhabitable, riddled with sinkholes silently swallowing the land and homes that perch precariously on these dumps.

The encroachment of coal mines on farmlands has become commonplace. Within the town of Ermelo, I met several farmers who have felt the brunt of the mining industry. The future of farming families living on top of rich mineral wealth is uncertain. Mines are unexpectedly opened with no public participation and they have in some cases begun operation in sensitive wetland areas. Farmers believe that people with high political connections are involved. With limited knowledge of the legal aspects of land reclamation for mining, numerous farmers have already lost their land.

Economic growth is taking place in South Africa yet the extreme discrepancies between wealth and poverty are still visible. With money to be made and the recent creation of several mining companies under the Black Economic Empowerment programme, political and economic lines are continually being blurred as individuals with close ties to government benefit from the mining industry, leaving in their wake very little for the majority of society to benefit from. The environmental and social impacts of mining bring with them major risks. Benefits are not always equitably shared, and local communities closest to the source of the mineral development can suffer the most. Mines do provide jobs in economically marginal areas but the opportunities are limited. Communities that come to depend on mining to sustain their economies are especially vulnerable to negative social impacts when the mine closes.

Alcoholism, prostitution and sexually transmitted diseases are still rampant in the mining hostels that lie adjacent to mines. Today some of these abandoned structures form part of an unseen community lacking employment and with poor sanitary conditions. These communities have very little or no relationship to the mines that were once in operation and have since closed.

Large quantities of waste from gold mining have had ongoing and disastrous consequences. Man-made mine dumps litter Johannesburg's skyline, adding pressure to a developing economy to find ways to tackle this latent environmental threat. Approximately 6000 officially listed derelict and abandoned mines lie dormant across South Africa, five times higher than the number of operational mines. Within these margins an illegal industry goes unnoticed. 'Informal miners', who are referred to as Zama-Zamas, undertake back-breaking work, risking death deep underground in abandoned mine shafts or on the mine dumps that litter the surface.

Informal settlements have a propensity to develop and grow on the peripheries and, in some cases on top of these uninhabitable wastelands. Such communities are at risk of air pollution exacerbated by the dust from coal mines, combustion resulting from burning mine workings or dumps, contamination of ground and surface water (acid mine drainage), and physical hazards posed by sites with open shafts and unstable ground. It is estimated that it could take up to 800 years for the rehabilitation of some mines.

Even though a project of this nature is far-reaching and covers a large expanse of the South African landscape, it has been tied together through microcosms of visual narration of untold stories.

Exploring the consequences of mining on South Africa's land and people, I am unsettled by what lies ahead. The need for economic growth cannot be ignored but neither can the sustainability of the earth and water for generations to come. Exploitation, corruption and greed threaten the land, the very thread that connects all South Africans. Once a symbol of wealth and a formidable force in the development of South Africa, the mine today reveals the scars of neglect and decay and as such poses an irreversible threat to our society.

Ultimately I hope that this body of work ignites discussion about how as a society we need to stand together in bringing about a broader understanding of our shared resources. We need to acknowledge that the environment is as fragile as the people who live on the land. Growth and development are prerequisites for economic stability, yet we must never forget the historical context of how we got here and how we should move forward into a balanced and equal future.

Ilan Godfrey
Cape Town, May 2013

Acknowledgements

First and foremost, my sincere gratitude goes to everyone who invited me into their lives, agreed to be photographed and shared their stories. Although all of the people and places could not be included in this book, I have tried my utmost to include many different perspectives and believe their message will be heard through others.

My heartfelt thanks goes to all the people who have helped me in one way or another in the development of this project. Without their knowledge, experience, passion and concern for the subjects and places I photographed, this project would not have been possible. Their generosity has been limitless, taking me into their homes, dedicating their time, and along the way I have built close friendships. Matthews Hlabane, Mariette Liefferink, Buti Botopela, Chabalala Petrus Charley, Malesela Phillipos Dolo, Jonathan Deal, Big Boy Mkhwanazi, Chris Molabatse, Dawid Markus, Alex Salang, Charmaine and Samuel van den Heever, Wendy Carstens, Andries Janse van Rensburg, Athol Stark, Engela Jeppe, Jaco and Jackie Nel, Daniel Jacobus Fourie, Oumakie Sekoere, Rankali Keketso, Johan Bezuidenhout, Johann Pretorius, Stephan, Hansie and Johan Roets, Diff and Lizette de Villiers, Pieter P. Hugo, Dirk Visser, André Roberts, Danie, Leonard and Dries van Wyk, Henryette Jacobs, Willie van Rooyen, Daniel Nzima, Elphus and Pauline Lubisi, Stanley Maseko, Ursula Franke, André Coetze, Willem and Annalie Theron, Anthony Barnes, Sol Bos, Jade Davenport, Liane Greeff, Dr Koos Pretorius, Anne Mayher, Brand Nthako, Erik Sekang, Micah Reddy, Sifiso Ndlovu, Sarel Keller, Dick Plaistowe, Bobby Marie, John Capel, Jeanne Hefez, Michael Raimondo, Hilton Hamann, Judith Taylor, Anouk Franck, Amanda Esterhuysen and Oros.

For making this book a reality and for the generous support in the completion of this project, my special thanks are extended to the funders, the Peter Brown Trust, the Gavin Relly Educational Trust, the Kirsch Family Trust, Orms, and the staff of the Ernest Cole Award and University of Cape Town Libraries, including Alyson Smith, Jon Riordan, Brian Müller and Kayleigh Roos.

I am particularly grateful for the assistance and advice given by David Goldblatt and Paul Weinberg, whose invaluable knowledge, inspiration and life-long experience were shared and who worked with me on putting together the final stages of this book.

This book would not exist without the team inside and outside Jacana Media. I would like to thank publishing director Bridget Impey and managing editor Kerrie Barlow for their commitment in working with me throughout the production of this book; Sakhela Buhlungu for his powerful and moving essay; Marius Roux for his patience and talent in designing the book; Russell Martin for his text editing skills; and André Heiberg for his digital print services.

I would like to thank all my friends and family for their belief in me and for supporting my work, together with those who have offered advice and shown support at various stages during the progress of this project, including Michal Singer, Greg and Leonie Marinovich, David Campany, Emma Bowkett, Max Houghton, John Fleetwood, Richard Lee, Jenny Altschuler, Guy Martin, Sean Wilson, Charlie Shoemaker, Ivor Prickett, Siobhán Doran, Johan Greybe and the staff at Kameraz.

A thank-you goes to Gert, Gerda and Stefanus at RGB Pixel Lab for their professional care in processing my film.

Finally, I wish to thank my parents Richard and Adrienne and sister Dalia for their encouragement throughout my life.

This book is dedicated to my wife Lianne, whose ongoing love and support have inspired and nurtured my photography from the very beginning.

Biography: Ilan Godfrey

Ilan Godfrey was born in Johannesburg, South Africa, in 1980. He has a BA (Hons) degree in Photography and was awarded the David Faddy Scholarship to continue his studies at the University of Westminster in London, where he gained an MA (Hons) degree in Photojournalism.

His work has been recognised locally and internationally by various photography awards, including the OPENPhoto Award in conjunction with the Open Society Initiative for Southern Africa, the International Photography Award, the Magenta Flash Forward Award, and Nikon Endframe Award, among others. In 2012 he was awarded the prestigious Ernest Cole Award to support the completion of his in-depth body of work, published as Legacy of the Mine, his first book.

He has participated in the Toscana Photographic Masterclass in Italy and is the recipient of the Ivan Kyncl Memorial Photography Placement in London.

Ilan's photographs have been exhibited in galleries and museums worldwide, including the National Portrait Gallery in London, the South African Jewish Museum in Cape Town, Iziko South African National Gallery in Cape Town, Wits Art Museum in Johannesburg and Musée du quai Branly in Paris. He works with various institutions and organisations worldwide and his photographs have been featured in a broad range of international publications.

Ilan's personal work focuses on extensive issues that reflect South Africa's constantly changing landscape, documenting the country with an in-depth, intimate and personal conscience. By conveying through long-term projects a process of exploratory narration with photography, he reveals varied aspects of societal change across the country.

www.ilangodfrey.com

Biography: Sakhela Buhlungu

Sakhela Buhlungu is professor of sociology and vice-dean for postgraduate studies and ethics in the Faculty of Humanities at the University of Pretoria. In 2011–12 he was Ela Bhatt Visiting Professor in the International Centre for Development and Decent Work at the University of Kassel, Germany. He has also taught sociology at the University of Johannesburg and the University of the Witwatersrand, where he was co-director of the Sociology of Work Unit (SWOP). From 2006 to 2007 he was head of the Department of Sociology at the University of the Witwatersrand and in 2012–13 he was acting head of the Department of Sociology at the University of Pretoria. In the 1980s and early 1990s he worked in the unions and in labour-supporting organisations.

Buhlungu has done research and published widely on the changing nature of trade unionism in South Africa and Africa, union movements' political engagement, industrial relations, political activism and the 'new' social movements. His most recent publications are *A Paradox of Victory: COSATU and the Democratic Transformation in South Africa* (UKZN Press, 2010), *Trade Unions and Party Politics: Labour Movements in Africa* (edited with Bjorn Beckman and Lloyd Sachikonye) (HSRC Press, 2010), and *COSATU's Contested Legacy: South African Trade Unions in the Second Decade of Democracy* (edited with Malehoko Tshoaedi) (HSRC Press, 2012; Brill, 2013).

The Ernest Cole Photography Award

The Ernest Cole Photography Award is a new award in South Africa, initiated under the auspices of the University of Cape Town Libraries, offering a unique opportunity for photographers to complete an existing project. The award, named after documentary photographer Ernest Cole, was made possible by the generous support of the Peter Brown Trust, the Gavin Relly Educational Trust, the Kirsch Family Trust and Orms.

Ernest Cole was born in South Africa in 1940 and received his first camera as a gift from a clergyman. Before leaving South Africa in the mid-1960s he worked as a photojournalist for *Drum* magazine, sharing a darkroom and friendship with the photographer Struan Robertson. On his own initiative Cole undertook a comprehensive photographic essay in which he showed what it meant to be black under apartheid. Out of this came the book *The House of Bondage*, which was published in New York in 1967 and immediately banned in South Africa. He never returned to South Africa and died in exile in New York in 1990.

Cole was a courageous documentarian who at times risked his life to share his imagery with the world. 'He wasn't just brave. He wasn't just enterprising. He was a supremely fine photographer,' said David Goldblatt, the renowned South African photographer.

The Ernest Cole Photography Award has been established to stimulate in-depth photography in South Africa, with an emphasis on creative responses to South African society, human rights and justice. The award is open to anyone whose work looks at South African society, with preference being given to people living within the country. The purpose of the award is to support the realisation of a significant body of work with which the photographer has been engaged.

For more information please see
www.ernestcoleaward.org.

This edition first published by
Jacana Media (Pty) Ltd in 2013

10 Orange Street
Sunnyside
Auckland Park 2092
South Africa
(+27 11) 628-3200
www.jacana.co.za

© 2013 photographs: Ilan Godfrey
© 2013 text: Ilan Godfrey and Sakhela Buhlungu

ISBN 978-1-4314-0861-0

Design and layout by mr design
Set in Leitura Sans, 9 pt
Job no. 002026
Printed by Craft Print, Singapore

See a complete list of Jacana titles at
www.jacana.co.za